Surviving Genocide

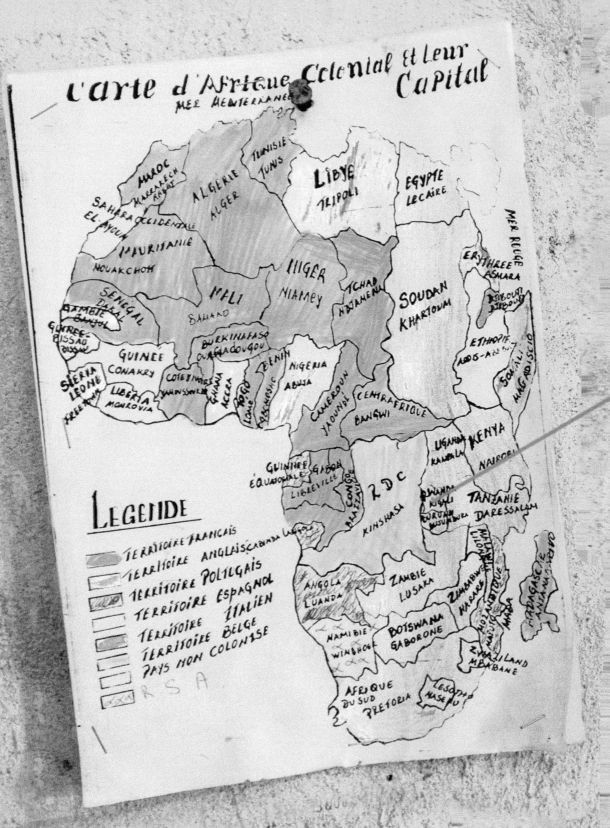

Carte d'Afrique Colonial et leur Capital

MER MEDITERRANEE

MAROC
MARRAKECH
RABAT

TUNISIE
TUNIS

ALGÉRIE
ALGER

LIBYE
TRIPOLI

EGYPTE
LE CAIRE

SAHARA OCCIDENTALE
EL AYOUN

MAURITANIE
NOUAKCHOH

NIGER
NIAMEY

TCHAD
NDJAMENA

SOUDAN
KHARTOUM

MER ROUGE

ERYTHREE
ASMARA

SENEGAL
DAKAR

MALI
BAMAKO

DJIBOUTI
DJIBOUTI

GAMBIE
BANJUL

BURKINA FASO
OUAGADOUGOU

ETHIOPIE
ADIS-ABEBA

GUINEE-BISSAU
BISSAU

BENIN

NIGERIA
ABUJA

SOMALI
MAGADISCIO

GUINEE
CONAKRY

COTE D'IVOIRE
YAMOUSSOUKRO

GHANA
ACCRA

TOGO
LOME

SIERRA LEONE
FREETOWN

LIBERIA
MONROVIA

CAMEROUN
YAOUNDÉ

CENTRAFRIQUE
BANGUI

UGANDA
KAMPALA

KENYA
NAIROBI

GUINEE EQUATORIALE

GABON
LIBREVILLE

CONGO
BRAZZAVILLE

R D C
KINSHASA

RWANDA
KIGALI

BURUNDI
BUJUMBURA

TANZANIE
DARESSALAM

ANGOLA
LUANDA

ZAMBIE
LUSAKA

ZIMBABWE
HARARE

MALAWI
LILONGWE

MADAGASCAR
ANTANANARIVO

NAMIBIE
WINHOEK

BOTSWANA
GABORONE

MOZAMBIQUE
MAPUTO

SWAZILAND
MBABANE

AFRIQUE DU SUD
PRETORIA

LESOTHO
MASERU

LEGENDE

- Territoire Français
- Territoire Anglais CABINDA LAGOS
- Territoire Portugais
- Territoire Espagnol
- Territoire Italien
- Territoire Belge
- Pays non Colonise
- R.S.A.

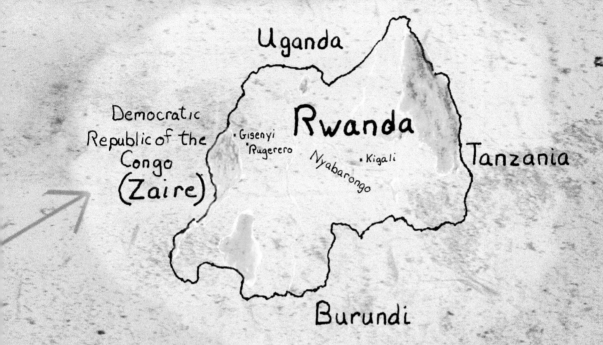

Uganda

Democratic
Republic of the
Congo
(Zaire)

Rwanda

·Gisenyi
·Rugerero

Nyabarongo

·Kigali

Tanzania

Burundi

Dedicated to the people of the Rugerero Survivors Village, Rwanda

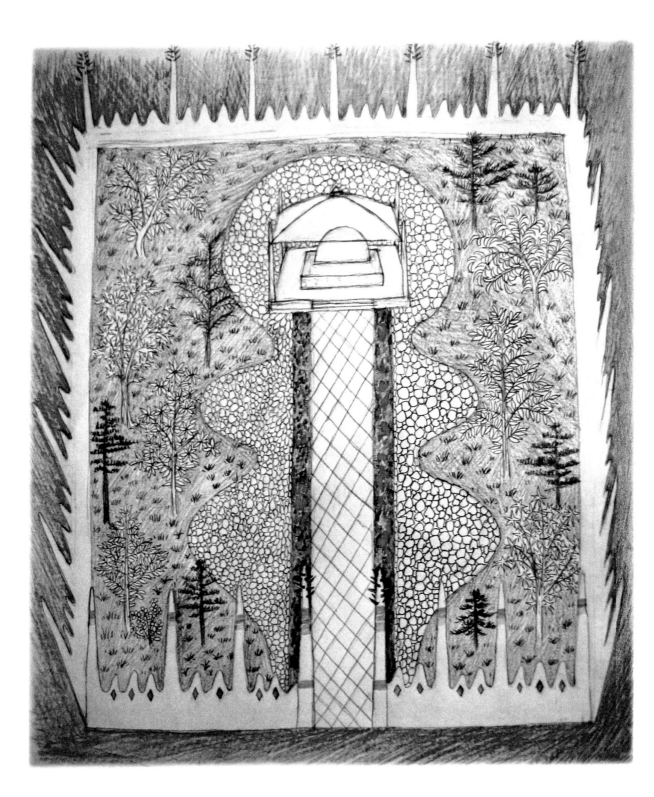

Healing from Genocide in Rwanda

Rugerero Survivors Village, an Artist Book

Susan Viguers and Lily Yeh

New Village Press • New York

Published in the United States by New Village Press
bookorders@newvillagepress.net www.newvillagepress.org
New Village Press is a public-benefit, nonprofit publisher
Distributed by NYU Press

Paperback ISBN: 978-1-61332-134-8
Hardcover ISBN: 978-1-61332-135-5

Library of Congress Cataloging-in-Publication Data

Names: Viguers, Susan T., author. | Yeh, Lily, author.
Title: Healing from genocide in Rwanda : Rugerero Survivors Village, an artist book / Susan Viguers and Lily Yeh.
Description: New York : New Village Press, [2021] | Summary: "The material in this heavily illustrated book stems from Lily Yeh's Rwandan Healing Project under the auspices of Barefoot Artists. That project included, among other things, drawing and storytelling workshops, from which the book draws. It tells the stories of two Rwandans who as small children experienced the 1994 Genocide. Their stories are framed by two chapters chronicling the transformation, in the Rugerero Survivors' Village, of a concrete burial slab into a Genocide Memorial with its bone chamber, designed by artist Lily Yeh and built by the villagers"-- Provided by publisher.
Identifiers: LCCN 2021014906 | ISBN 9781613321348 (paperback) | ISBN 9781613321355 (hardcover)
Subjects: LCSH: Genocide survivors--Rwanda--Personal narratives. | Genocide survivors as artists--Rwanda. | Rwanda--History--Civil War, 1994--Atrocities.
Classification: LCC DT450.436 .V54 2021 | DDC 967.5710431--dc23
LC record available at https://lccn.loc.gov/2021014906

Contents

Part 1 Meditation — The 1994 Genocide against the Tutsi: Rugerero, Rwanda 2

Part 2 Uwicyeza Nyayisenga Angel: Her Story 38

Part 3 Musabyimana John Peter Sammy: His Story 70

Part 4 Remembrance and the Living 102

Epilogue and Credits 126

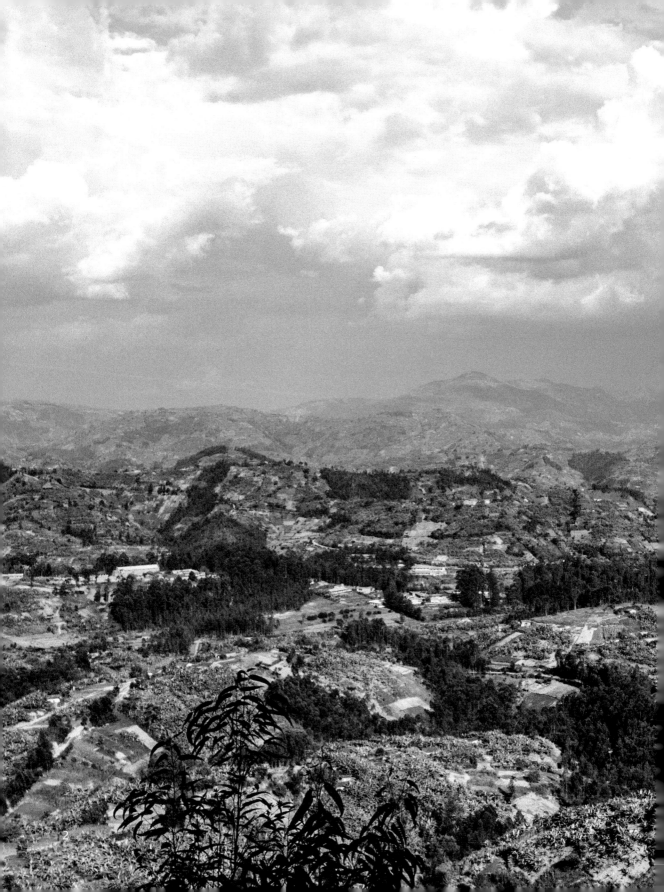

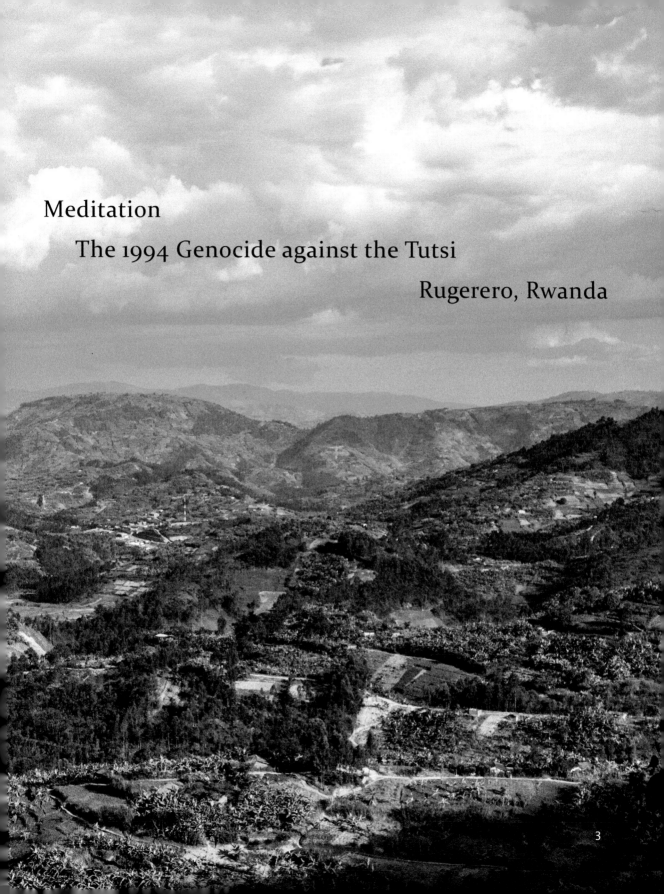

Meditation

The 1994 Genocide against the Tutsi

Rugerero, Rwanda

IN 1994 FROM APRIL 6 THROUGH MID-JULY, approximately 800,000 Tutsi and moderate Hutu sympathizers were killed in Rwanda.

The genocide didn't emerge suddenly. Genocides rarely do. The long colonial period, with Belgium as the primary player, had a major role in perpetuating tension between the Tutsi and Hutu. Ethnic or class violence, beginning in 1959, was common after Rwanda's independence in 1962.

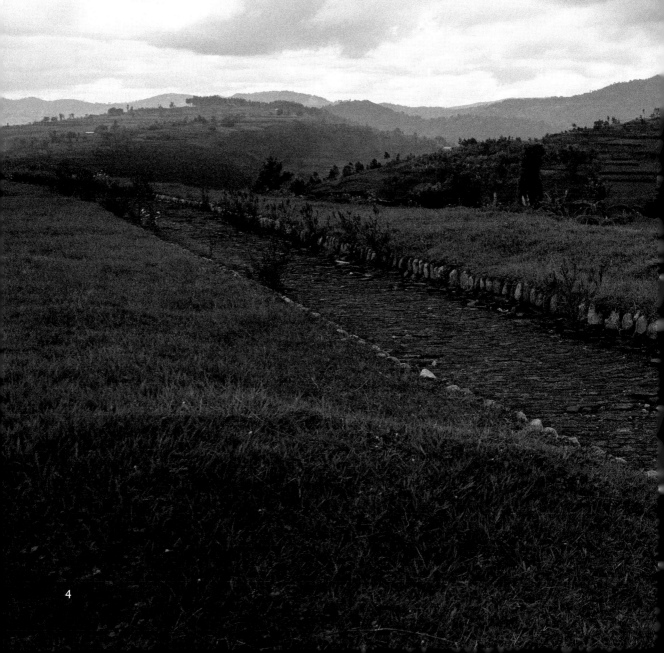

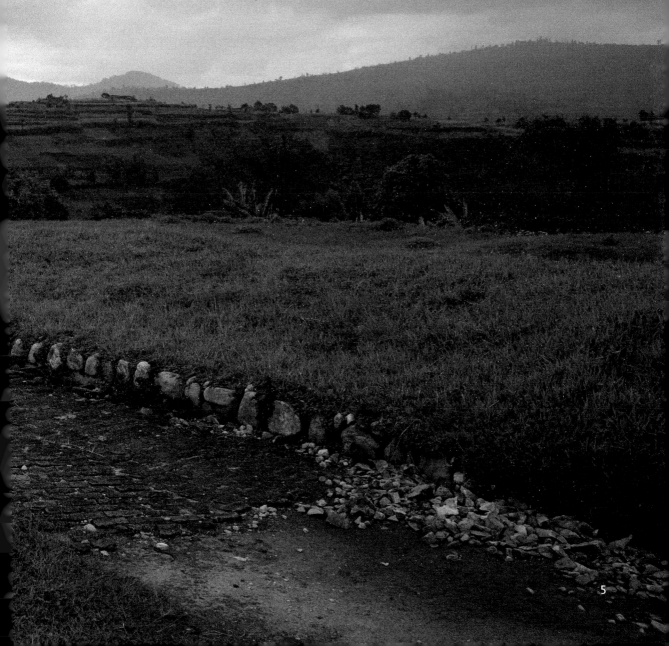

However, the 1994 Genocide against the Tutsi carried out mostly by two extremist Hutu militia groups, the Interahamwe and the Impuzamugambi, was the largest organized killing of human beings in the shortest period of time in modern history. Its brutality and destruction left marks all over this small, verdant country.

Years later, everyone who survived carries the trauma of genocide.

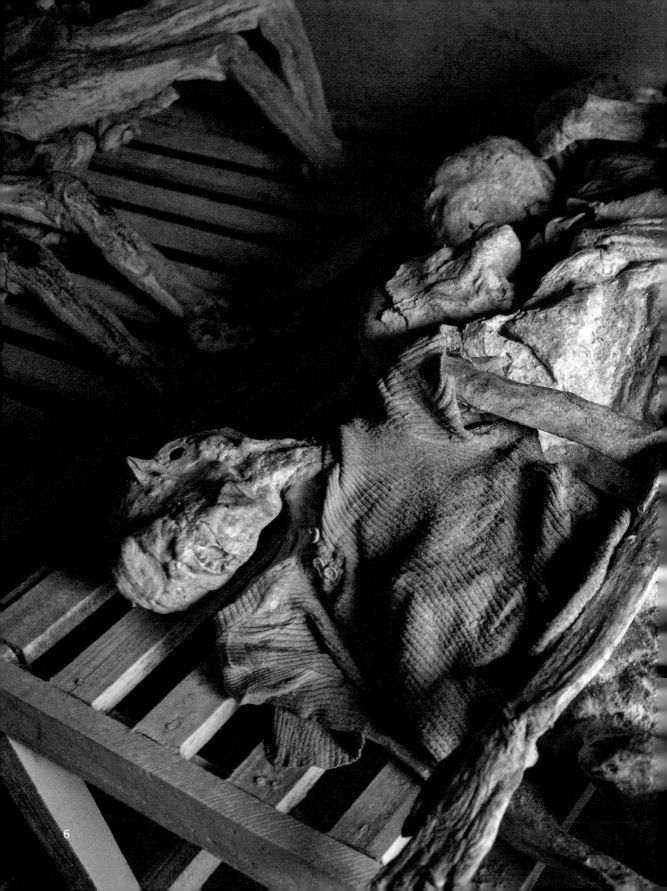

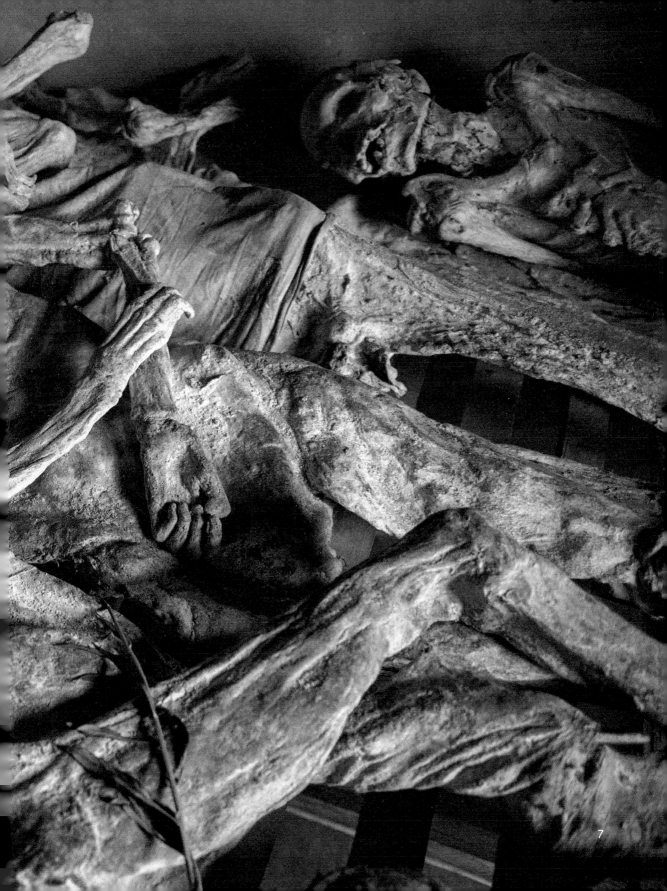

A prerequisite for genocide is the total dehumanization of the other.

This genocide was seen as the extermination of *inyenzi*
— of cockroaches.

Where in our world and our history, including the present,
have there not been massive atrocities?

What is it about humankind that is capable of that?

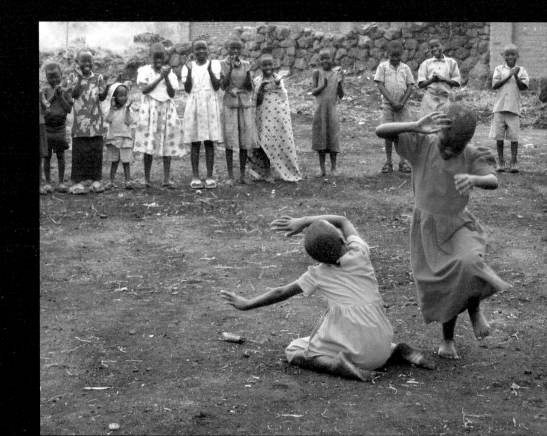

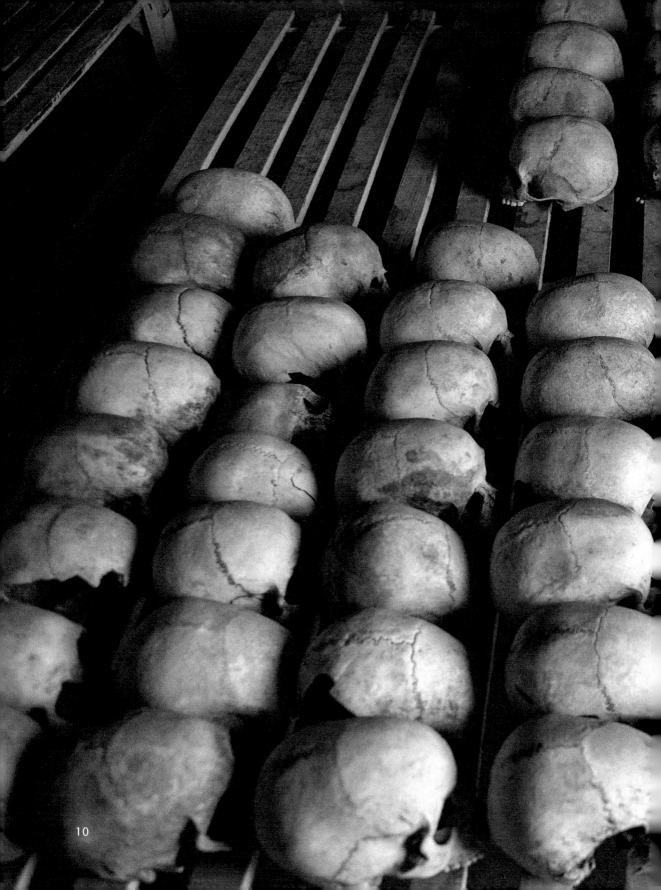

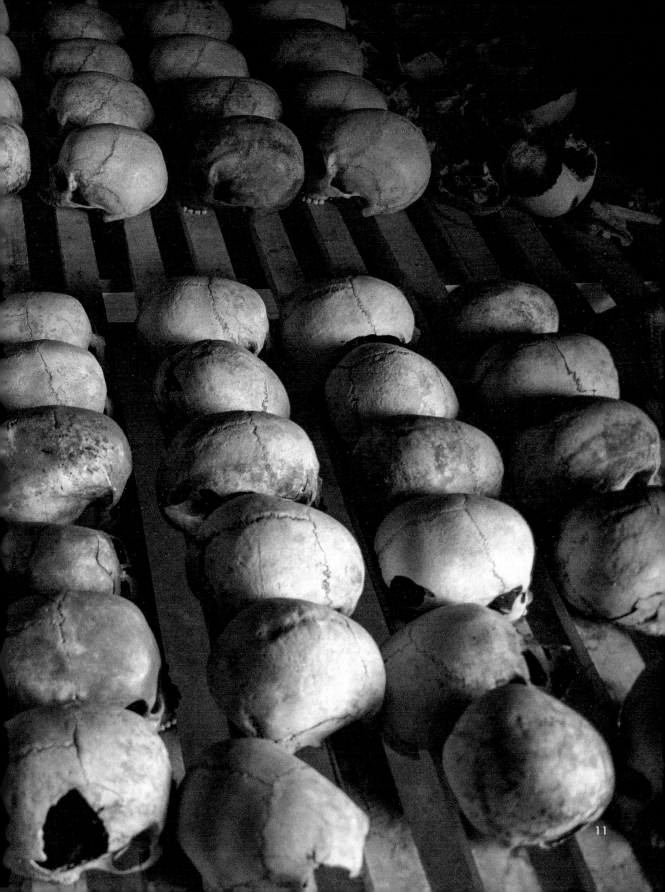

Honoring the dead is necessary for the humanity intrinsic to civilization, even one glorifying war. Homer's battle-heavy *Iliad* ends not with Achilles' victory over the Trojan Hector, but with his god-inspired gift to Hector's grieving father of his son's body and a ten-day truce for the funeral.

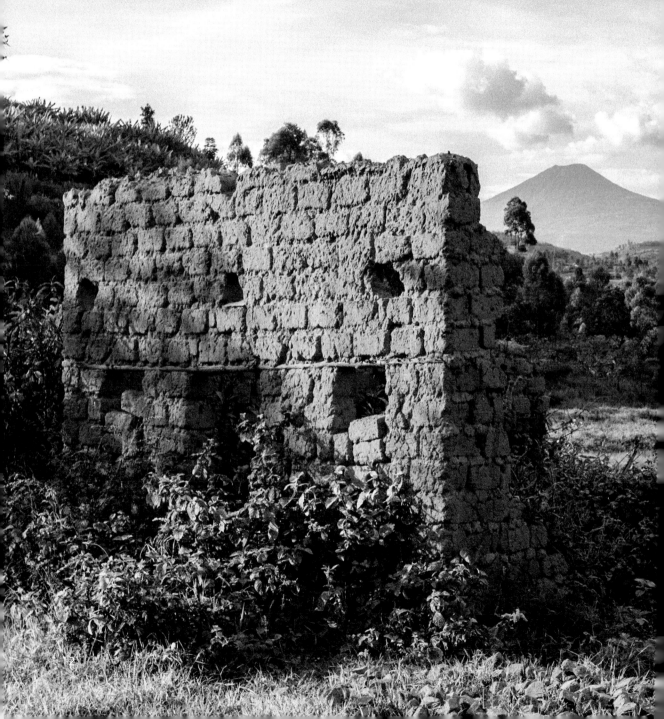

The denial of the Armenian Genocide in Turkey has had repercussions long past the immediate grief of the death of loved ones, relatives, and community.

The various public memorials to the Holocaust, including the Remembrance Day declared by the United Nations, anchor the survivors, their descendants, and the attendant world in *memory – the dead remain with us –* and *this must not happen again.*

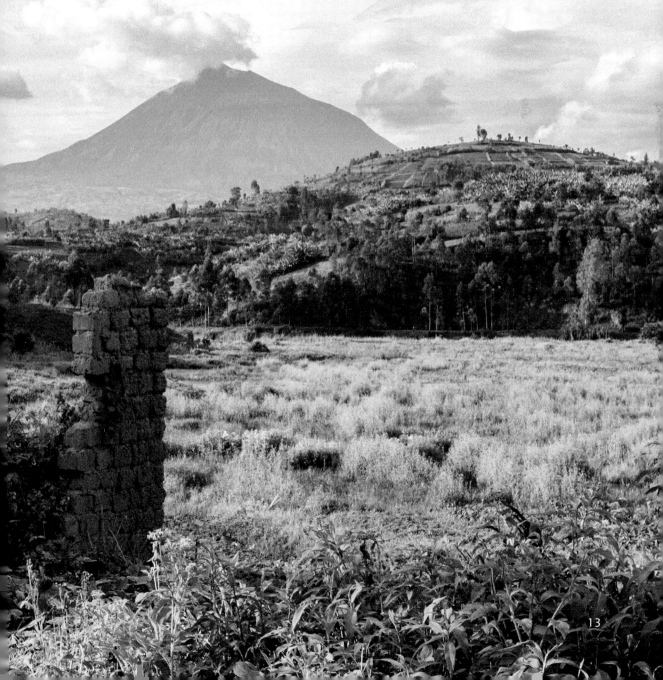

Those who escape are survivors, but surviving is not living.

For living, there must be healing.

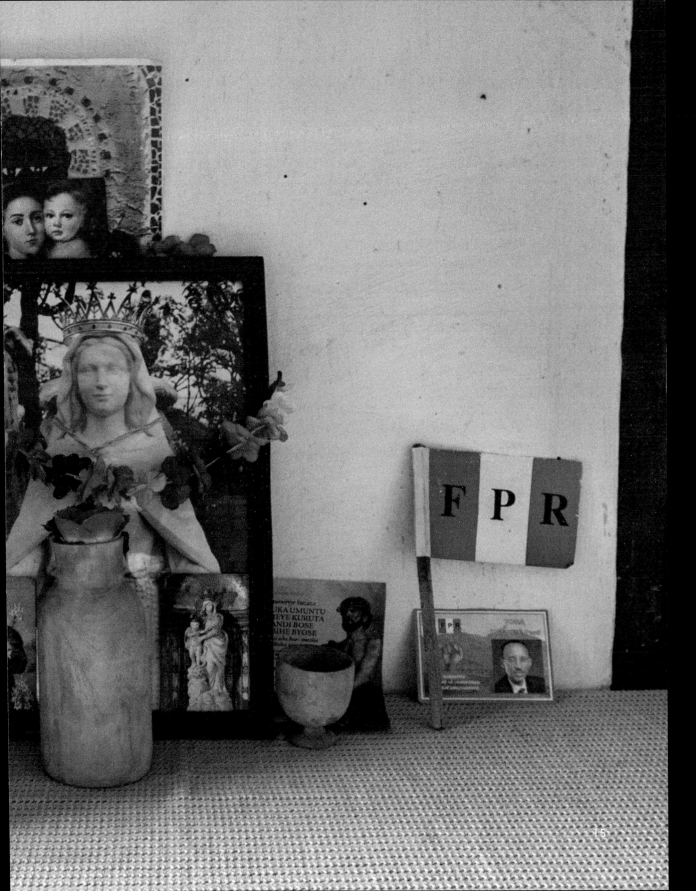

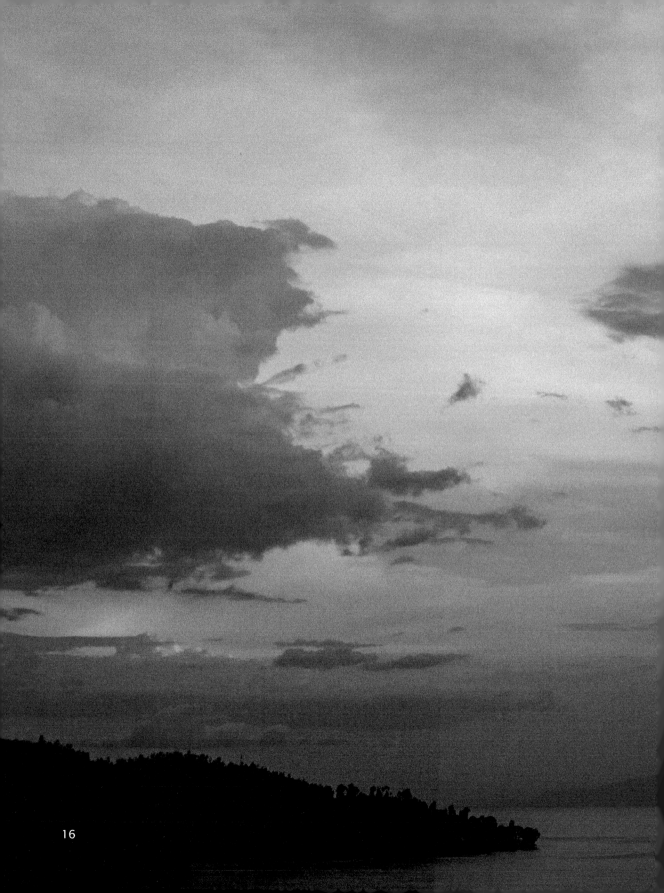

Remembrance, honoring the dead, allows for new life.

In Rugerero, a sector in the Western Province of Rwanda, Rubavu District, years after the 1994 Genocide, the only memorial to the dead was a rough concrete unmarked mass gravesite.

Mukagatare Melanie voiced the pain of the survivors: "To have our loved ones' bodies stored in a dirty place, soaking in the mud during the rain – it was as if we were killed twice."

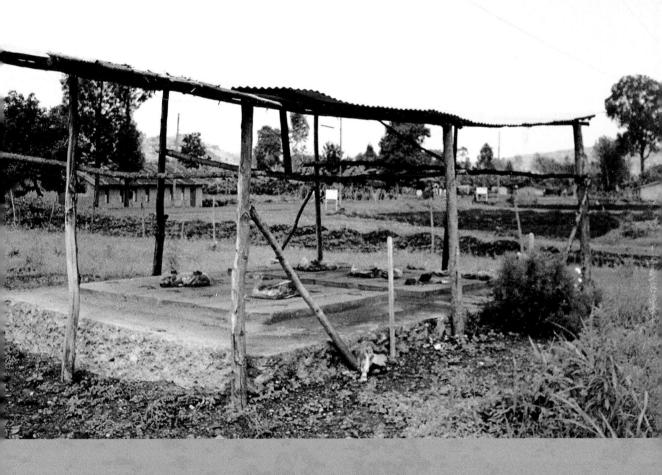

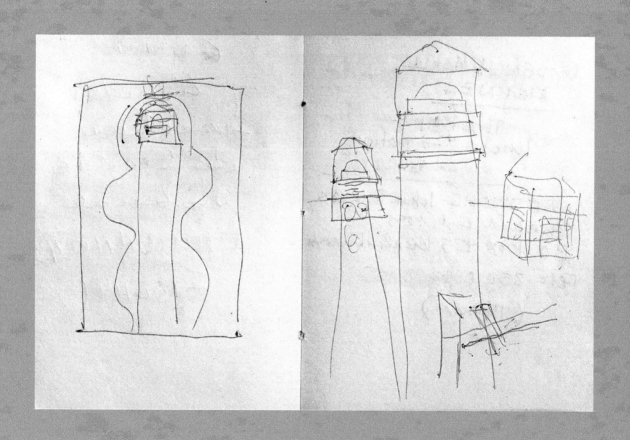

Sketches of the Rugerero Genocide Memorial Site by Lily Yeh

Guided by Lily Yeh's vision
and aided by Jean Bosco Musana of the Rwandan Red Cross,
by the China Road and Bridge Construction Company,
and under the auspices of the Barefoot Artists Organization,

Rugerero villagers, local workers, and volunteers

transformed the grave into a sacred space.

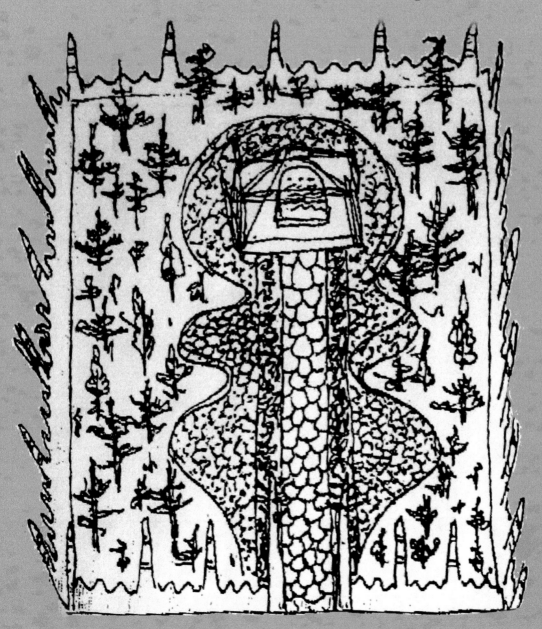

Nyirangezahayo Jeanne
Born 1971, Kibuye

"We were five people before the 1994 Genocide.
Now there is only me."

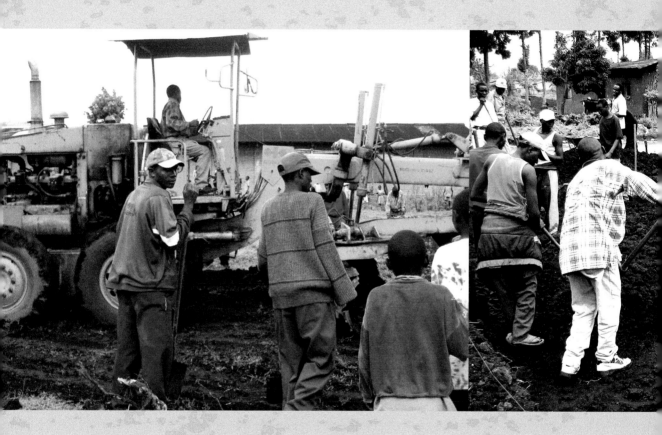

Mukamana Justine
Born 1984, Eastern Province, Gatsibo District

"We were a family of nine people
Only three survived."

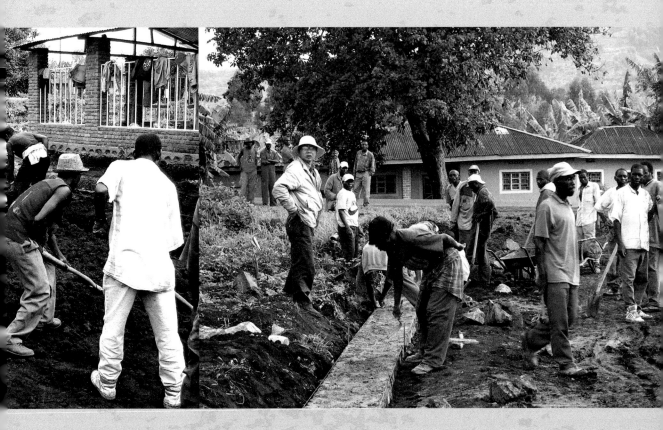

Uwizeyimana Jacqueline
Born 1979, Rubavu District, Nyamyumba sector, Kinigi cell, Byima Village

"We were six people before.
We are now three."

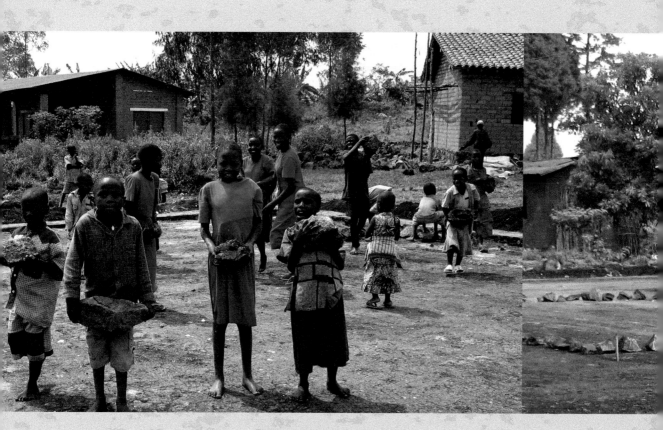

Mukagasana Marie
Born 1976, Western Province, Rubavu District, Gisenyi Sector

"We were seven children, two boys and five girls.
Now we are only four girls. Both parents died too."

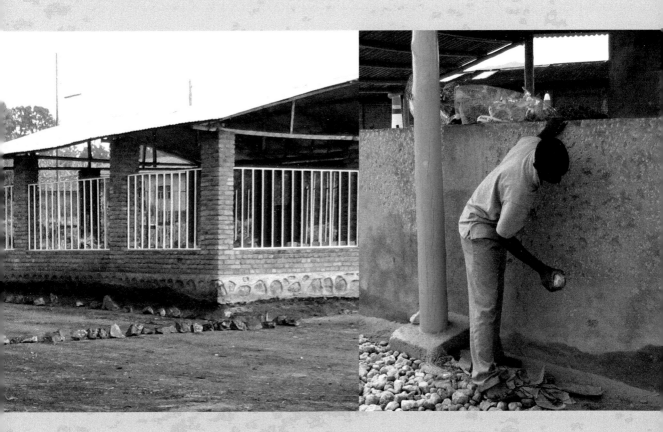

Indihafi Jane
Born 1992, Rubavu District, Rugerero Sector

"We were thirteen people in the family.
Only four survived."

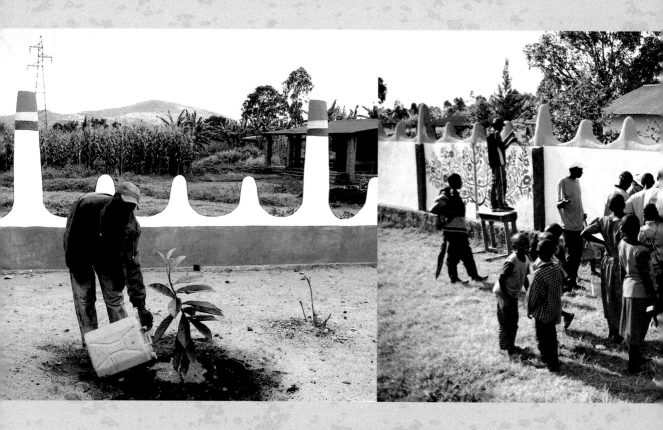

Uwamahoro Francine
Born 1989, Western Province, Karongi District

"Before the 1994 Genocide there were seven people in my family.
We all survived. It was extended family who died."

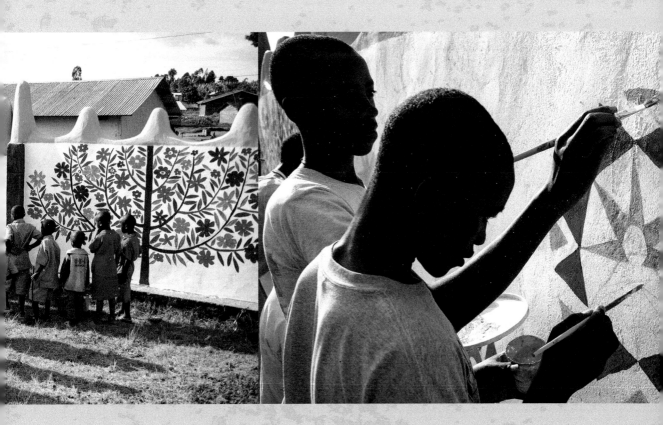

Imanishimwe Françine
Born 1986, Karongi

"We were nine.
Five of us survived."

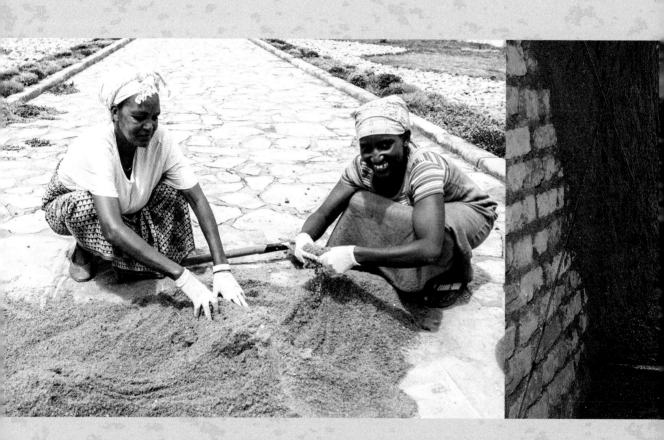

Nirere Claudine
Born 1985, Rubavu

"We were five in the family..
Two people suvived."

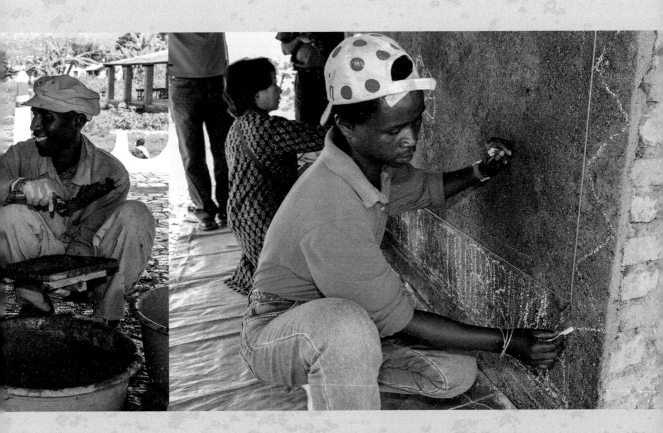

Uwingeneye Dina
Born 1974, Western Province, Nyabihu District, Mukamina

"Before, we were eight people.
Only four survived."

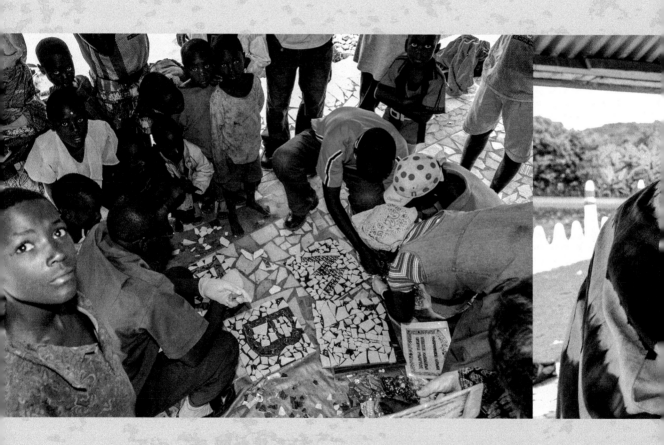

Umutesi Solange
Born 1988, Rubavu District, Busasamana Sector

"We were a family of six people before the 1994 Genocide. Five survived. Only our mother died."

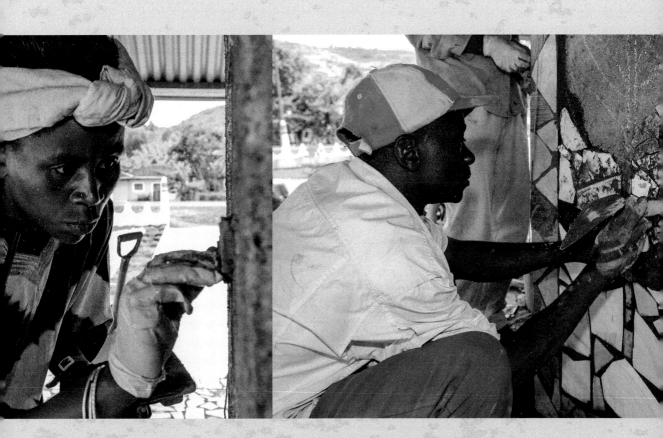

Niyonsaba Esperance
Born 1978, Western Province

"We were eleven.
Six of us survived."

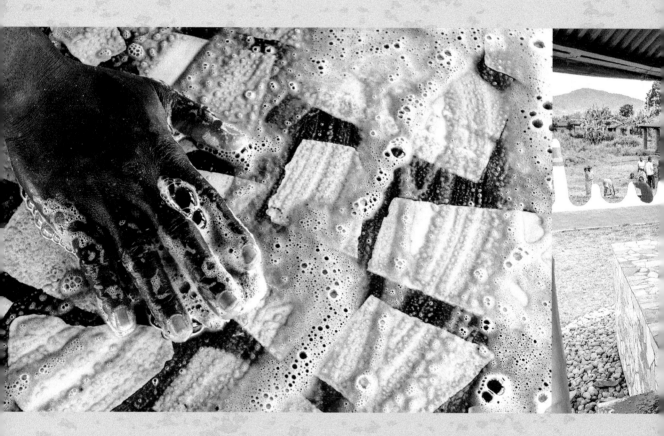

Nyiraneza Alexia
Born 1982, Kibuye

"We were seven people.
Three people survived."

Uwicyeza Nzayisenga Angel
Born 1989, Gitarama

"We were four in the family.
After, it was only me."

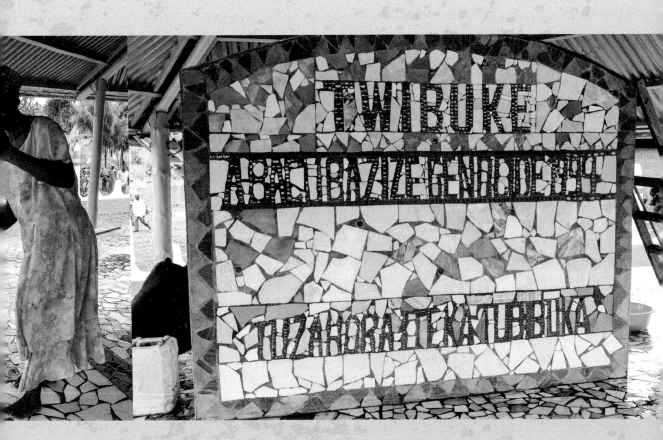

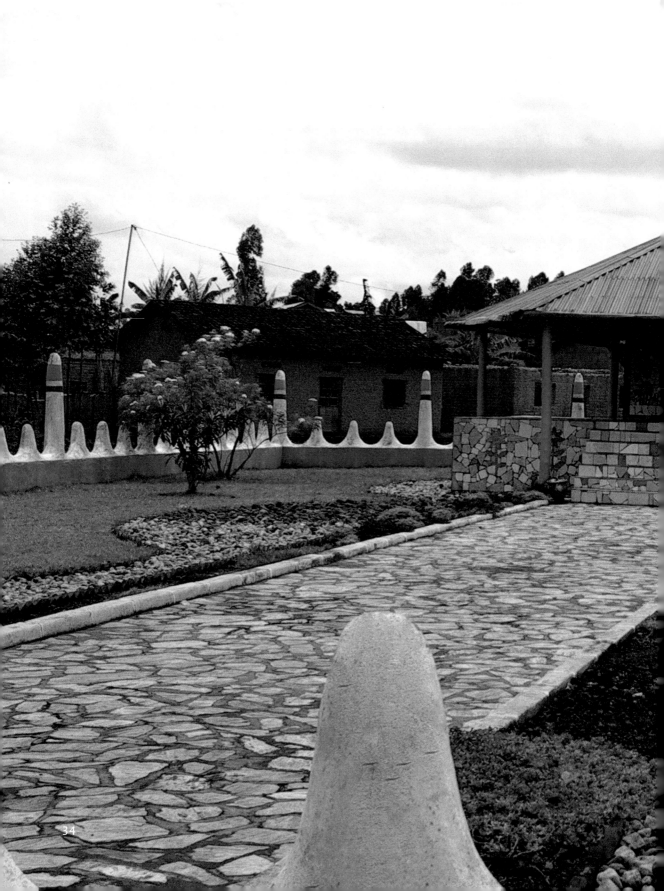

Rugerero Genocide Memorial Site, 2007

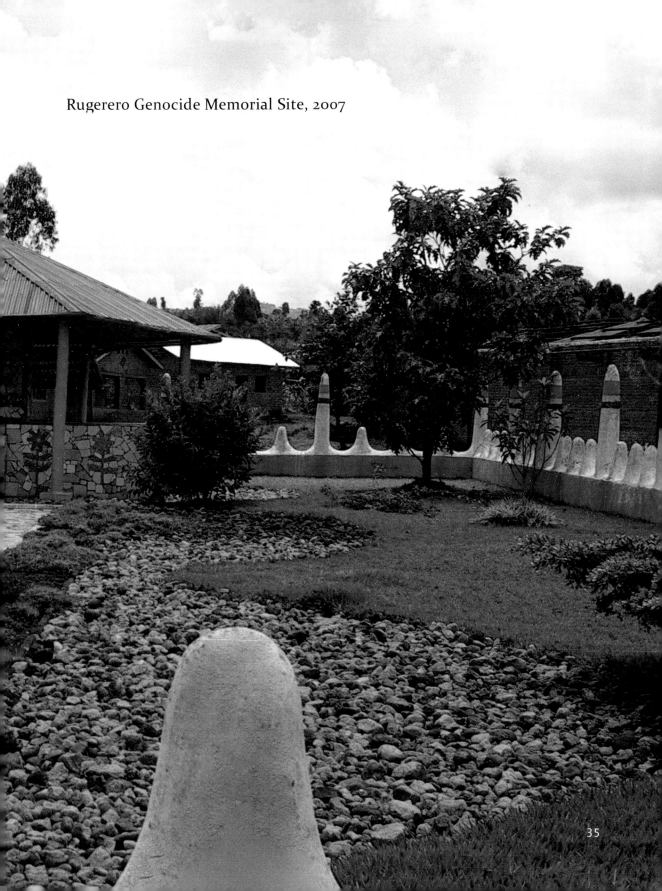

Homily

From the start, the forces were unequal; Satan a grand seigneur in heaven, Job mere flesh and blood. And anyway, the contest was unfair. Job, who had lost all his wealth and had been bereaved of his sons and daughters and stricken with loathsome boils, wasn't even aware that it was a contest.

Because he complained too much, the referee silenced him. So, having accepted this decision, in silence, he defeated his opponent without even realizing it. Therefore his wealth was restored, he was given sons and daughters — new ones, of course — and his grief for his first children was taken away.

We might imagine that this retribution was the most terrible thing of all. We might imagine that the most terrible thing was Job's ignorance: not understanding whom he had defeated, or even that he had won. But in fact, the most terrible thing of all is that Job never existed and was just a parable.

Dan Pagis
Stephen Mitchell, trans.

The stories of Uwicyeza Nzayisenga Angel
and
Musabyimana John Peter Sammy
are not parables.

They are real; they happened.

This book is witness.

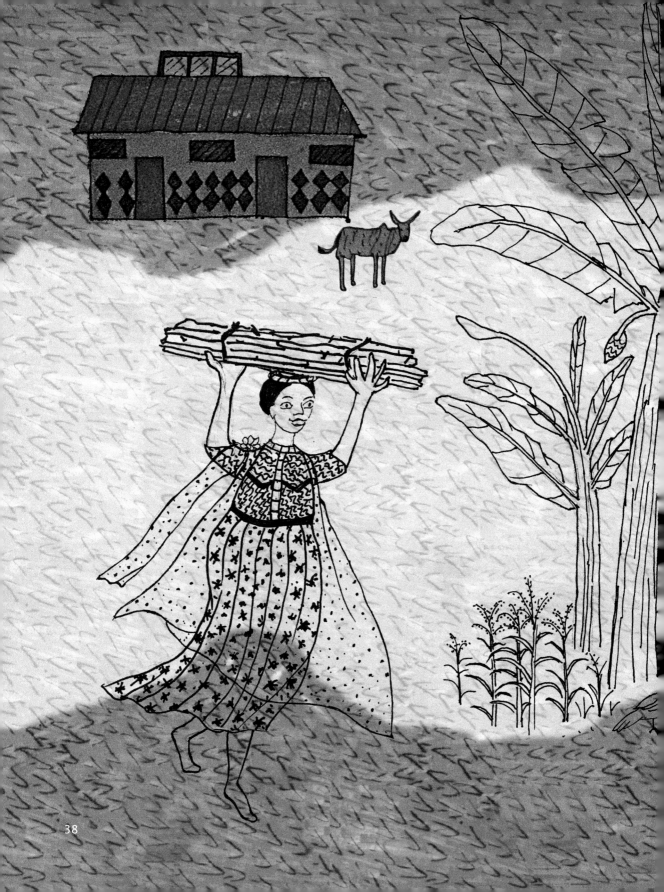

Uwicyeza Nzayisenga Angel
Her Story

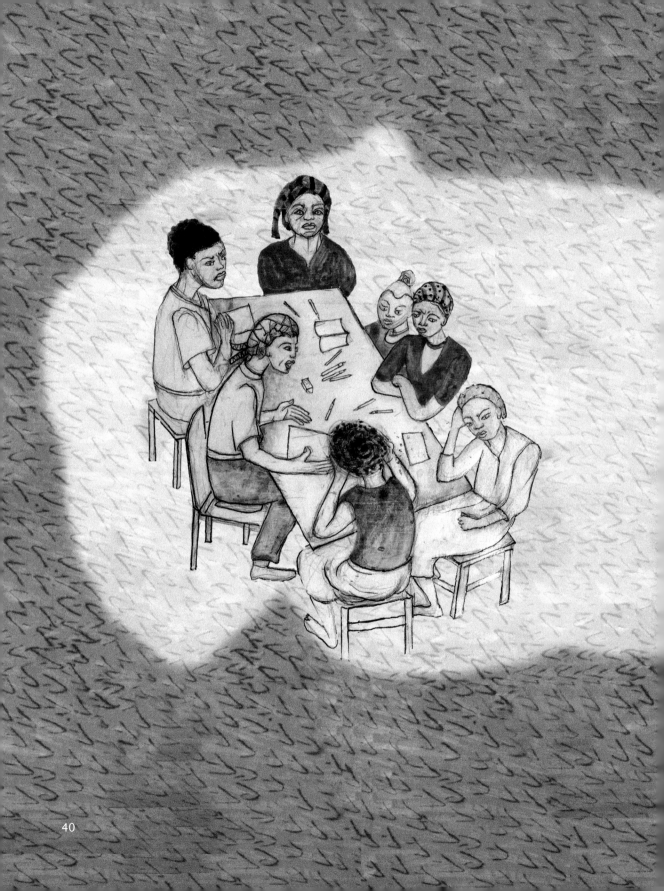

Chapter 1
First impressions

Uwicyeza nzayisenga angel was perhaps the most withdrawn, the quietest, of the twelve young women from Rugerero Survivors Village, with whom Lily Yeh was working through a program to teach sewing and more recently storytelling through drawing workshops.

When the first workshop began the mood was intense and dark. The women sat looking down, stone-faced. Some began to cry. Knowing the women were devote Christians, Lily asked them to hold hands and someone to pray for guidance and protection.

Then softly the group began to sing.

She knew the women had probably never held markers in their hands or drawn before. Their first drawings were awkward and minimal. Nonetheless, many of them, although not Angel, began to share their stories.

The first time Lily saw Angel smiling was in an outdoor workshop under the shade of big trees in the courtyard in front of the main administrative office of Rugerero. Curious children gathered to watch as blue and green patterned mats were placed on the thick grass and the women started to draw. Nadine Rukatsi, the translator, began to clap her hands and sing. Children followed. The atmosphere was festive, and Angel had joined in the singing.

The following year Lily came back with images of Indian folk artists
for inspiration. For two weeks she held, in the morning, storytelling
and, in the afternoon, drawing workshops. She showed them other
artworks, including those by Frida Kahlo and Holocaust survivor
Esther Nisenthal Krinitz.

She could see the women gaining confidence in their
drawing and even enthusiasm for telling their stories.
But Angel remained remote.

Chapter 2
Her drawings

Lily hadn't particularly noticed Angel's drawings. They were sticklike, the lines tentative and fragile, images seemingly placed at random, and the passages accompanying them were spare, the briefest of identification, rarely more than a sentence.

That changed when she read the translation of the words
on the drawing next to a figure in yellow lying in a pool of
blue and a tiny red figure without arms:

> *This is a friend I was running away with.*
> *They killed him and threw his body in the water.*

And next to the red form:

> *They cut off this person's arms and cut him on the*
> *back too. But he survived.*

There was terror behind Angel's silence.

45

Over time Angel's pictures became more vibrant, with color and intricate patterns, suggestive of folk artists, filling in any empty space. But, with the exception of very few of her drawings, they were all, along with her first sketches, of her family and village life before she was six – before the 1994 Genocide.

When Lily began to read these fragmented lines, she wondered
how they could become a personal story.

Milk bottle used most often to offer milk to visitors, which
made them very happy.

Traditional containers used when going to visit people to
put groceries in.

This picture shows my mom and dad holding me when I
was a baby.

This is when my mom and dad took me to the hospital
because I was sick. There were lots of people who had come
for treatment. We had to wait in a long queue before the
doctor gave us medicine and we could go home.

When I got healed I played soccer with other neighborhood
kids. When we were done we would talk about school stuff.

I am home with my mom and dad. I have a ball in my hands
and they are teaching me how to play with it.

Children coming home from school and playing along the way.

My grandfather is visiting, telling me stories.

My mother making porridge, preparing maize, pounding
cassava leaves.

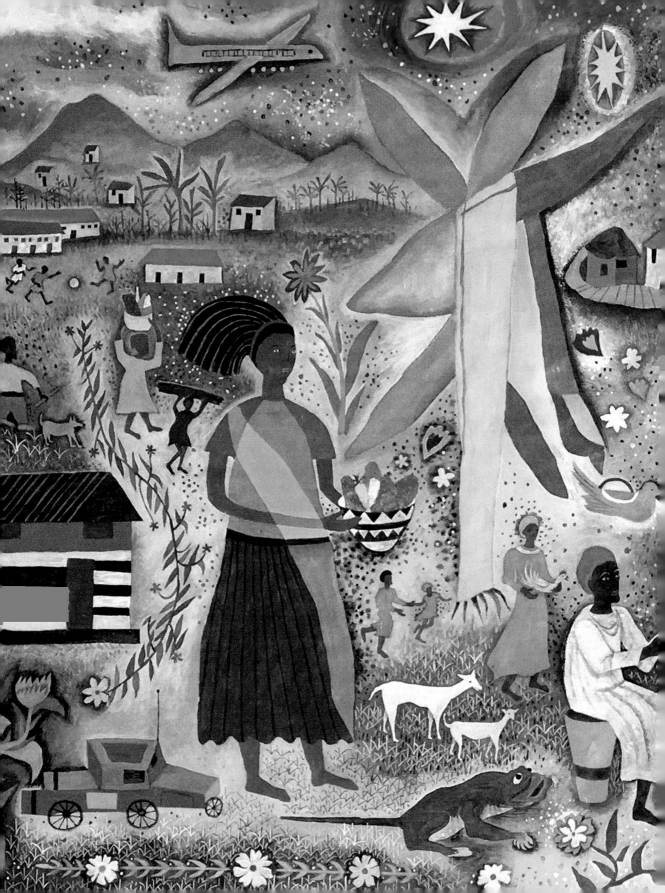

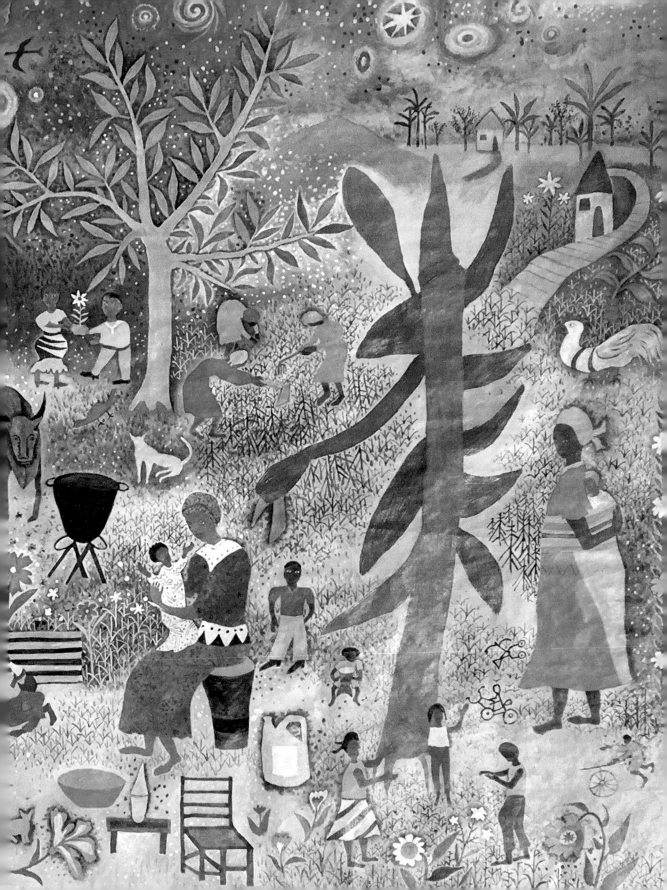

At times the horror behind the small red figure
would show itself, but in the end, Angel was
one of the few in the group who did not create
in images and words a full story of her life.

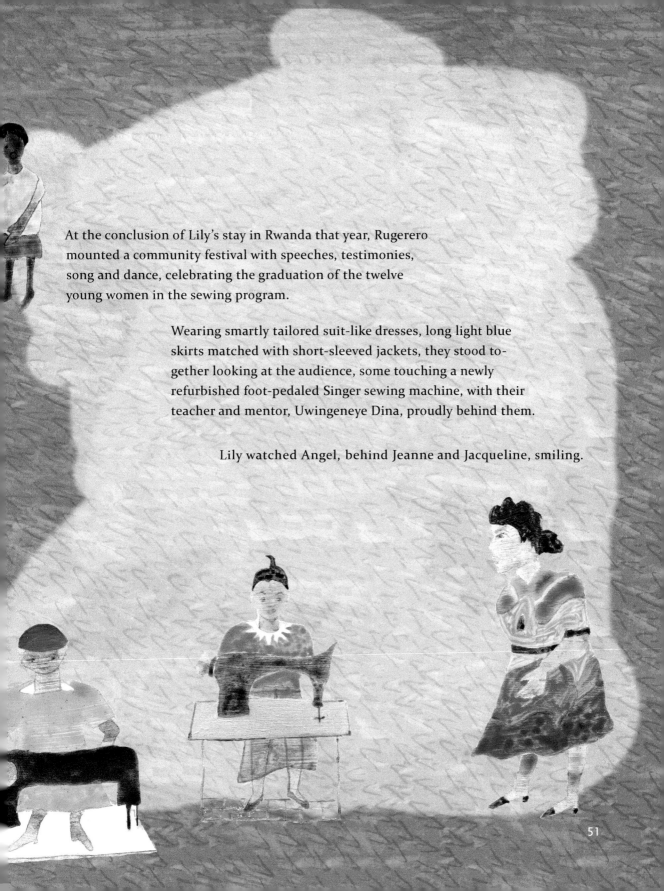

At the conclusion of Lily's stay in Rwanda that year, Rugerero
mounted a community festival with speeches, testimonies,
song and dance, celebrating the graduation of the twelve
young women in the sewing program.

Wearing smartly tailored suit-like dresses, long light blue
skirts matched with short-sleeved jackets, they stood to-
gether looking at the audience, some touching a newly
refurbished foot-pedaled Singer sewing machine, with their
teacher and mentor, Uwingeneye Dina, proudly behind them.

Lily watched Angel, behind Jeanne and Jacqueline, smiling.

51

CHAPTER 3
The interview

TWO YEARS LATER LILY was now interviewing all the young women in the group. That day it was Angel who would be interviewed.

Lily approached the clay brick house, with her translator, Rudasingwa Felix, with apprehension.

When they entered what first struck her was the explosion of color. A rich blue patterned couch, a red cloth hanging on the wall, and over the rest of the walls murals.

Page spreads of African animal scenes, cutout images not only of animals, but plants, and maps, and Bible story figures, sometimes humorous, a brilliant green tree hovering above blue water, a dog perched on the nose of a porpoise.

Lily had brought some of Angel's drawings with her. She hoped
they would help lead her into telling more of her life, more of
her story. After settling down, Lily asked Felix to suggest that
Angel describe some scenes in her pictures.

"Here is my mom making porridge," responded Angel. "The
person you see with the panga is the one who came with the
intention to kill my mother and grandfather. But on that day, he
didn't do that. They used to come at night and throw stones at
our house."

"These were our neighbors with whom
my family used to share so much."

"You must have been terrified," said Lily.

"When they threw stones," Angel continued after Felix's translation, "my mom would go out to see what was happening and I would hide under a bed. Sometimes they would come during the daytime and say they wanted to kill my mother. I was always with my mom, so I thought they would kill me also.

"They killed my mother while she was pounding cassava leaves we would have eaten that night."

With that, Angel stopped.

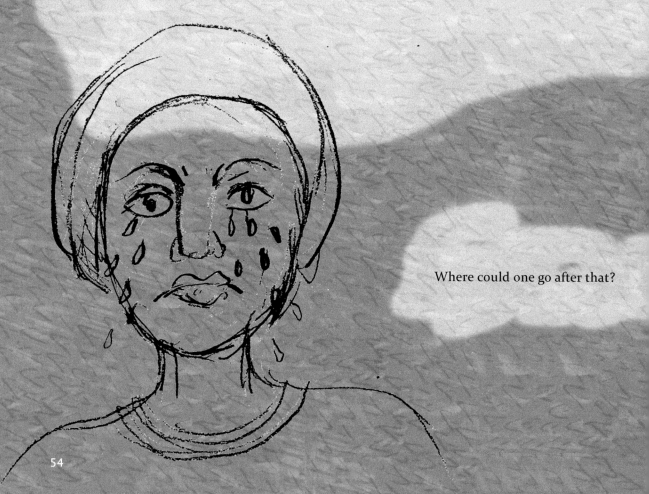

Where could one go after that?

Anxious to break the silence and remembering Angel's description
of her grandfather telling them stories and bringing them treats, Lily
turned to Felix. "She's talked fondly of her grandfather. Could you ask
her about him?"

"My grandfather was killed before my mother. It was after that that
they came and killed my mother."

The time lapses for translating questions and answers broke up any
natural flow of conversation. Angel's voice was also so low that Felix
and Lily had to struggle to hear, and making it even harder was the
fussing of a child in another room.

His crying seemed to Lily a score for Angel's story.

Did her child, deep down, know the family tragedy?

Was he crying for his mother and his family?

On the wall near Angel's chair was a picture
of Jonah being swallowed by the whale.

Chapter 4
By the River Nyabarongo

ANGEL WAS TELLING HER STORY now without questions to
prompt her.

"At that time we were living in Gitarama and my father was
in Kigali, working as a doctor. That year, 1992, they killed my
mother, saying she was a traitor.

I sat there all alone with my younger brother, waiting for my father.

"My father had to get a house girl for us. We stayed home with
her while my father continued in Kigali as a doctor. When the
massacring of the Tutsi started in 1994, my father came back
to pick us up so he could take us as refugees to the convent of
nuns in Kigali."

Not only was her child now crying
loudly, but Angel had begun to weep.

"On the way to Kigali, when we reached the river Nyabarongo we met a roadblock.

"They ordered my father out of the taxi. I was sitting in the front seat by the driver. 'Whose is this child?' they asked him. 'She's my daughter,' the driver replied, but, not believing him, one pulled me out.

"Another took my father and caught my brother with the other hand.

"They killed my brother and then my father.

They cut off his limbs, one by one. Then they cut off his head.

"I fell down and the body of my father fell over me. When they saw the blood all around my body, they thought that I was also dead.

"They pulled us to the bushes to get the bodies off the road and threw my father's head into the river."

You were only six years old!" Lily exclaimed. "How did you manage?! You had no food!"

"I stayed with the body of my father over me for two days. Then I was thirsty. I crawled slowly out and drank water from the river, using my hands, and crawled back and again slipped under him. I knew no one and had nowhere to go.

"When the soldiers of RPF found me, one side of the body had started rotting."

RPF:
The armed wing
of the Rwandan
Patriotic Front

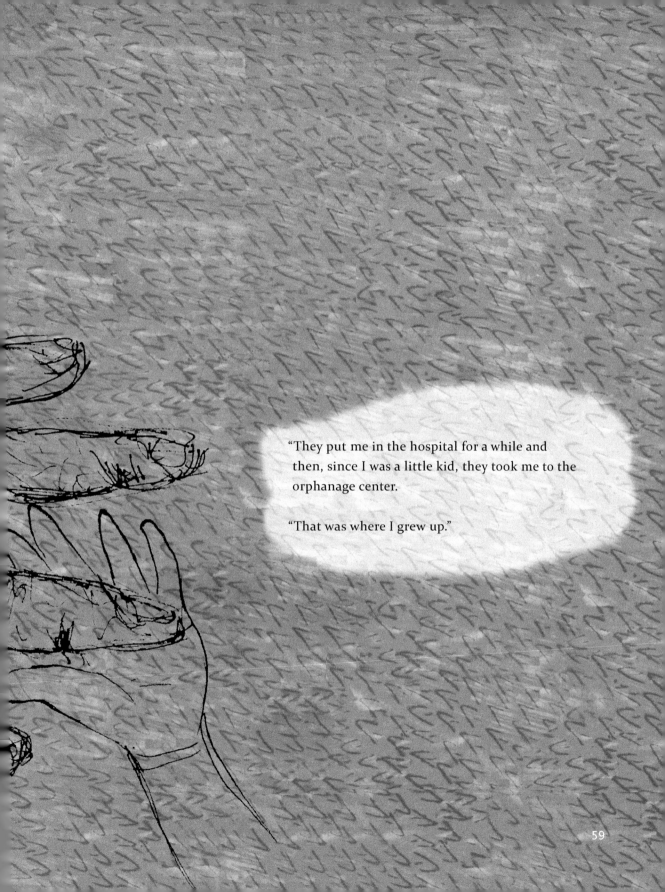

"They put me in the hospital for a while and then, since I was a little kid, they took me to the orphanage center.

"That was where I grew up."

CHAPTER 5
Living with the horror

"HOW DO YOU LIVE with all this horror!" asked Lily.

> "That was why I did not continue school. Every year when the time came . . . every year in April, I would be in the hospital. I would be ill and stay there for a month or two.

> "Even now, when that time comes, I feel like not going anywhere or seeing anybody. That time is a time of mourning. I stay in my house; I don't want to see people."

> The child's crying had stopped,
> as had Angel's weeping.

"Have you found the bodies of your parents, your grandfather, your little brother?" asked Lily.

> "We buried my grandfather, but my mother, my brother, and my father – I don't know where their bodies are."

"Do you want to continue to search for them?"

"There is no way of finding them.

"They killed my mother at a roadblock. They took my mother's body and showed everyone in the village so that they could see what a Tutsi looked like.

"I don't know where her body is. As for my father, I couldn't even try to search for him. He was thrown into the river."

"And your little brother?"

"My little brother went with my father."

"Does telling your story help at all?"

"Telling it releases me, but it also takes me time to recover. Like now, when I talk, I remember what it was like. For a month I will feel that I am not like others. So it relieves me, but after a long period."

The child in the other room
had again begun fussing.

"Would it help to write a story about your father? Even though you were so young when he died. You could talk about his name and maybe what he looked like and things he used to do. You could remember your father, your mother, your grandfather, your little brother individually. Maybe that is one way to honor them.

"Would you like to do that next time when I visit?"

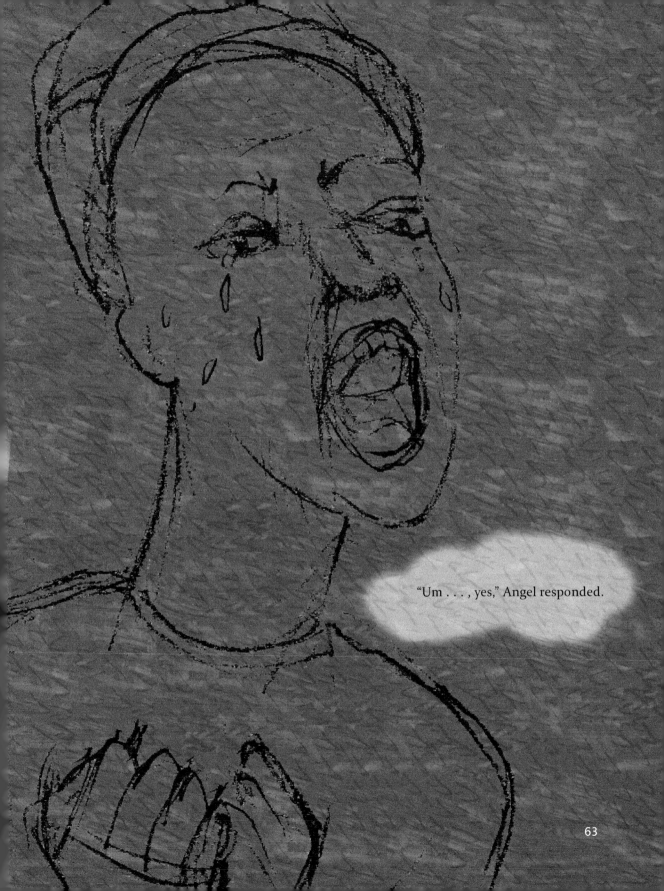

"Um . . . , yes," Angel responded.

Chapter 6
Angel's dreams

"WHAT ARE YOUR DREAMS for yourself and your children?"

> "My children will be fine because my husband has a job and I can now say I can get a job because I have learned sewing. With that money and his job, we will share the work of our house and our children. My wish is that my children live a good life and I have a happy family."

"Do you have any other dreams?"

> "Another dream I have is to recover the bodies of my parents so I could bury them."

Gacaca:
A community court system, set up after the 1994 Genocide, with the dual goals of bringing about justice and reconciliation

"Isn't it still possible through Gacaca to find them?

"You must find them!"

Her child was now
crying in earnest.

"I have to go," Angel replied.

"My hope is that when you come back to Rwanda next time,
you will find we are okay and healthy."

65

A couple of weeks later, when Lily was again about to leave Rwanda, Angel expressed the hope that, during the next anniversary of the Genocide, Lily would come with her to the river Nyabarongo to remember her father.

Nothing could have touched and honored Lily more.

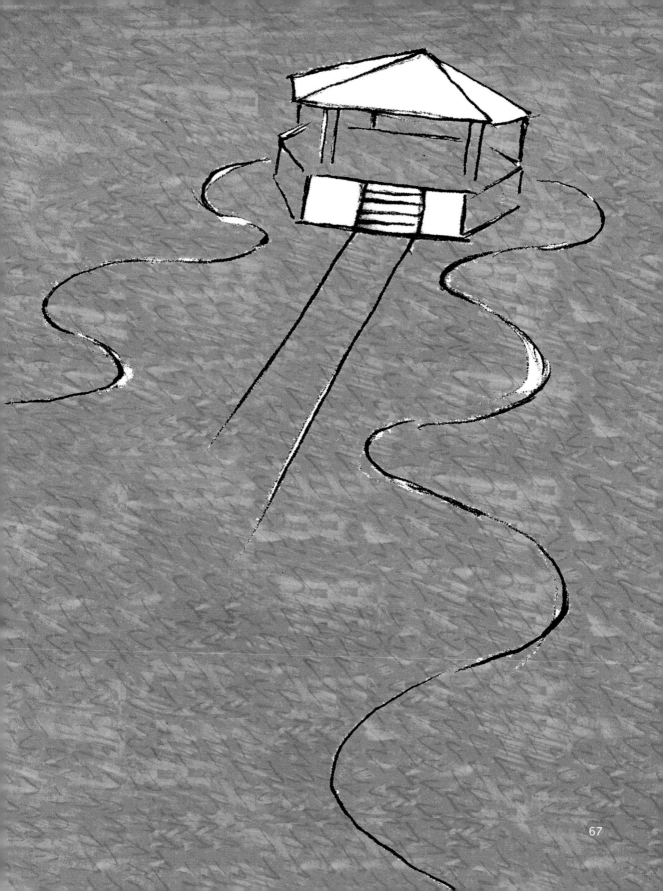

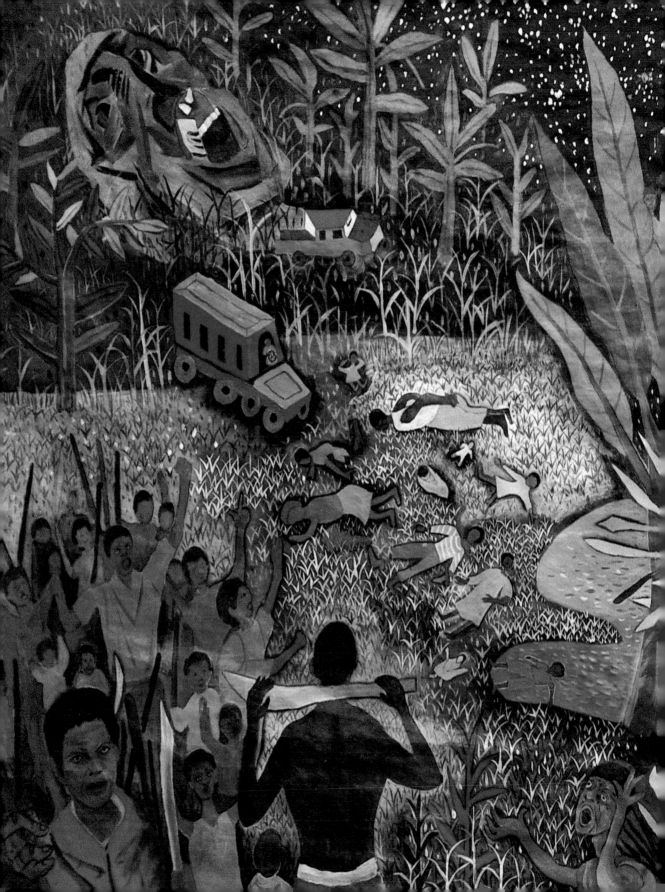

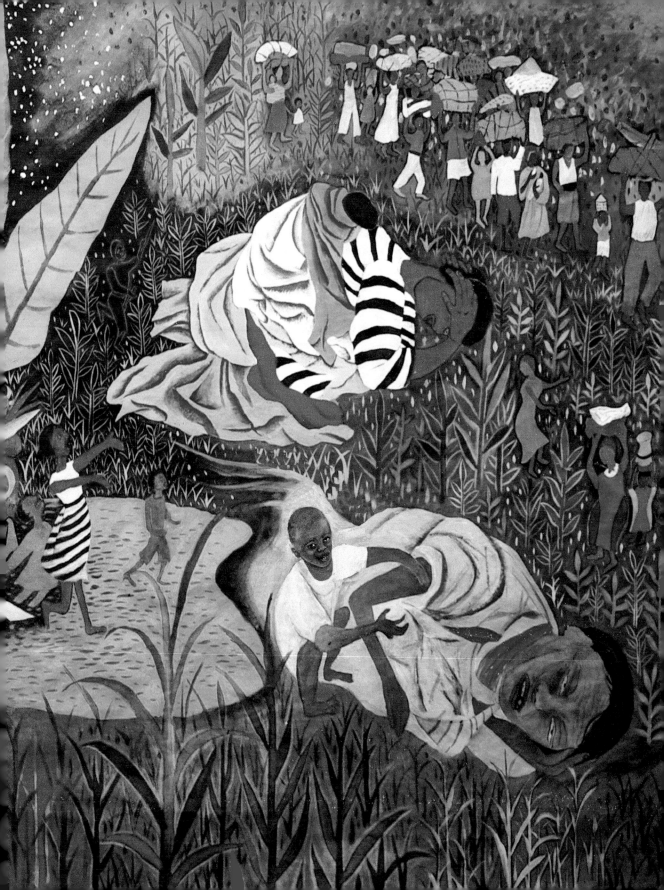

Géjeje mu rugo, barongera Bamusi...

hira ki mwica Ubwo Tabiri Bamusa...

turimba bagegeyo barongera haturu...

Umwica barongera ba...mu

Ga Centre (Sante) Taraho haturu

Umwica ubwa... Nibwo bamu fatag...

...yo... imbere yo mu rugo Aho twari...

dutuye

Nari Aho licfit mu Giti cya Avo...

cyo mu murima w'... kimwe Hou... twir...

dutuye Ba...

...

Nibwo... je Interahamwe e...

...Samuyango...

70

Musabyimana John Peter Sammy

His Story

72

Chapter 1
My life with my mother before the war

MY MOTHER WAS QUITE A PERSON before the war, with her husband Habyarimana Simon.

After they had two children, my father died, and a little while later his family told her she had to leave. She took my younger brother and me to her mother, Nyirabinenywa Anastasia, who lived by herself. She was the only child in the family and her father, Sengorera, had given her his property, which was in the former Rubavu Commune, Murara Sector, Kabere cell.

My father did not die a normal death.

In 1959 Tutsi houses began to be burned and looted. Some Tutsi fled to different countries – Uganda, Kenya, Tanzania, Congo, USA, Europe. Many who stayed in Rwanda were tortured and killed. A Hutu could commit a crime and then say that it was a Tutsi who did so. Then the Tutsi would be killed, like one man I knew, Musema.

My father was killed in 1982. People said he had come from Uganda to help the Inkotanyi. I was two years old then and my brother was only a few months old.

We continued to stay with my grandmother. But it turned out that she was poisoned as early as 1985. Her feet and legs swelled. We tried to treat her but nothing helped and she died in 1991.

Inkotanyi:
Tutsi rebel army, with roots in the Tutsi refugee diaspora

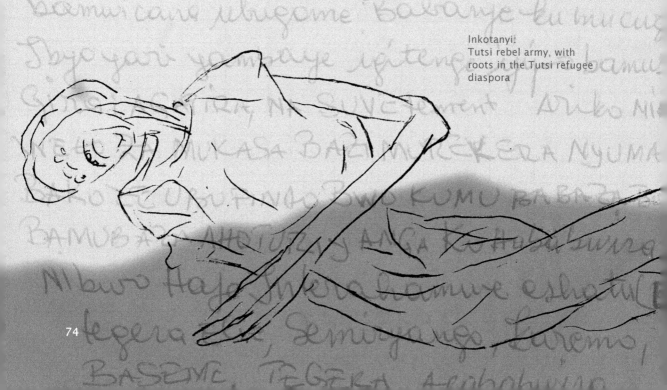

When my brother was in primary 2, he told my mother that in his class the teacher would tell the Tutsi to come to the front and the Hutu to remain in their chairs. Then when they stood in front, the teacher used a pen to measure their noses to see whose nose was longest and to check ankles and palms for veins.

They were training the Hutu children to discriminate.

That was a very bad period for all the Tutsi who stayed in Rwanda.

It was October 1990 when the RPA soldiers attacked.

RPA:
Along with RPF, acroynm for the armed wing of the Rwandan Patriotic Front

75

Chapter 2
My mother saw that her friends hated her

LIFE WENT ON WITH OUR MOTHER. She treated all people the same, regardless of tribes, Tutsi, Hutu, and Twa.

But our only neighbors were Hutu.

My mother was determined that we would eat, which meant that she was constantly looking for ways to feed us. People started saying that we were Inkotanyi and that my mother was sending money to support the Inkotanyi. How could she be doing that when she was such a poor and weak woman?

Neighbors and friends started to distance themselves from her saying that she was a traitor. They called every Tutsi a traitor. Mother told us to be careful and to stop wondering about her supporting the Inkotanyi. I knew she had no means to do that.

Twa:
Early inhabitants of Rwanda, about 1% of the present population

76

My mother was a person who prayed to God to have the strength to endure. Sometimes when she asked for a job, she was refused, and after work sometimes, she would go to buy food, but they took her money without giving her goods.

Then we spent a night without food.

In the night people would throw stones at our house, on the roof and at the doors, shouting.

"You snakes. We will kill you. You cockroaches.
 When the time comes, we will eliminate you."

They told my mother that it was only that the day had not arrived. She would say to us, "My children, calm down. The day has not arrived that they warned us about.

 "Only then we die."

Then they came to our house at night and took everything. They broke my mother's back and took her money.

They told her that they would come back for those sons of hers.

They bragged that they even killed her mother. That's when we understood that they were the ones who had killed our grandmother.

Our family would fade away.

By then I was 10 years old and my brother 7. Various political parties started meetings – CDR, MRND, MDR, and others I don't remember. Murara sector, Kabere cell, was a very dangerous place, because the Hutu held many meetings there.

CDR, MRND, MDR:
Coalition for the Defense of the Republic,
National Republican Movement for Democracy,
Democratic Republican Movement

My brother remembers that they often passed by our house and threw stones at our roof, singing:

"We will finish them off. No Tutsi will escape us."

Their aim was to kill all the Tutsi so that in years to come a Hutu child would ask, "What does a Tutsi look like?"

On the last day of the meetings they killed a person because he supported "cockroaches," cutting him up into pieces. This threatened my mother, but she did not know what to do. She told us the next day that those who killed him were rewarded by the government because they showed a good example.

"When your father was killed," she told us, "nothing was done."

Chapter 3

How our mother committed herself to us

MY MOTHER TOLD ME that I must take my brother and go into hiding. They started killing on April 6th at 10 p.m. We learned about it around noon on the 7th. We refused. My mother got a stick and beat us, crying, "Do you want to die, too?"

I was frightened and she caught my hand and joined it with my brother's and prayed for us. "Take care of yourselves," she said, "and may God protect you. If we don't meet again here on earth, we will meet in heaven."

And she told us to laugh.

It was April 8, 1994.

Shortly after our separation, we heard loud shouting. "Nikuze is caught!" Our mother was Nikuze Agnes.

It was around 2 or 3 p.m.

They asked her where we were.

She refused to tell them.

They beat her on the head. From everywhere – children, women, and men – all together yelling at her, but

<div style="text-align:center">she refused to tell.</div>

They walked with her through two sectors, everyone yelling at her. No one offered her water. When they reached the cemetery, no one offered to kill her. They brought her back and people yelled at her like to a thief. When they reached our home, again, there was no one who wanted to kill her.

A second time they took her to the cemetery. But no one would kill her. They brought her back to a place near the trading center. But no one would kill her.

The third time they took her to a spot near our home. We were in an avocado tree in the garden next to the house. She was clearly very badly hurt. They undressed her and left her with only underpants and continued to torture her, asking where her sons were.

<div style="text-align:center">She refused to answer.</div>

Then came four Interahamwe – I could see them from the avocado tree – four neighbors I knew: Tegera Elie, Semiryango, Kerem, and Baseme.

Tegera told the others to move away so that they would not get covered with blood. Then he beat my mother with a rod until she collapsed. He cut her neck with his panga and speared her in the ribs.

Then they left her. Even her ex-friends left her – without even covering her.

Slowly I came down from that tree and went into the house. Nobody saw me. Fearfully, I brought out a blanket. When I covered her, I realized that she was still breathing.

Interahamwe: Hutu paramilitary organization, translated as "those who stand, work, fight, attack together"

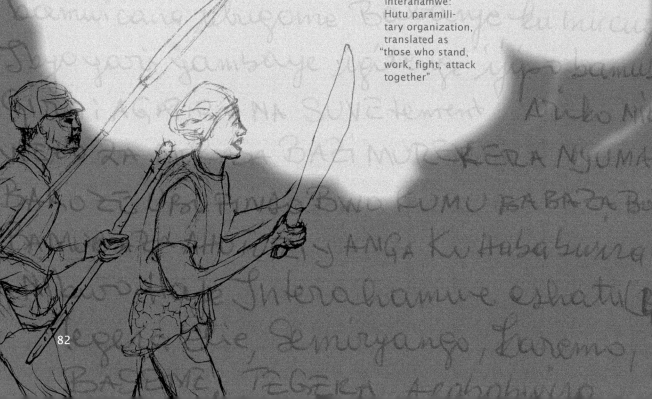

"Run! Get away from here!" she whispered.

"I am already dead, but you must live. You go and protect your brother.
And when you survive, love others as I have loved you."

Then she died.

There was no one to comfort us.

Everyone wanted to kill us.

CHAPTER 4
How I lost and found my brother

AFTER THE DEATH OF MY MOTHER, I took hold of my brother's hand and ran to hide in another place, in the bushes. In the morning we went to a nearby church where our mother went to pray. The members of the church warned us that if we stayed there the Interahamwe would come and kill us. I told my brother that we had to go back into the bushes.

I left him there and went to look for food and eventually found raw sweet potatoes. After eating them, he needed water. I got some from a banana tree and we drank. Then we went and slept in the tree that stood in front of our home. Our mother's body was still there.

The next day we realized that they might see us. So we left and hid in a bush on the roadside. We could see them moving with machetes, spears, and clubs.

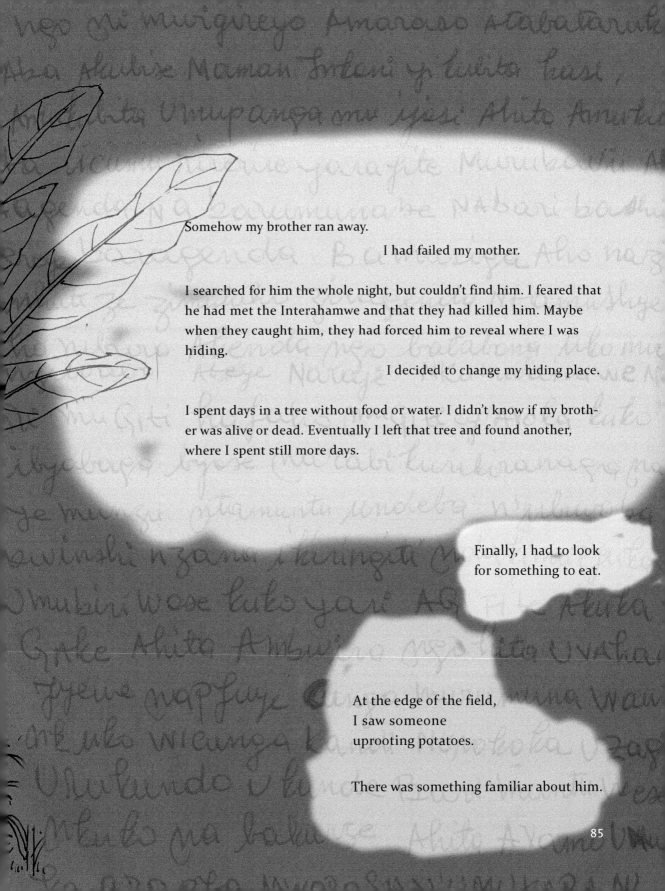

Somehow my brother ran away.

I had failed my mother.

I searched for him the whole night, but couldn't find him. I feared that he had met the Interahamwe and that they had killed him. Maybe when they caught him, they had forced him to reveal where I was hiding.

I decided to change my hiding place.

I spent days in a tree without food or water. I didn't know if my brother was alive or dead. Eventually I left that tree and found another, where I spent still more days.

Finally, I had to look for something to eat.

At the edge of the field, I saw someone uprooting potatoes.

There was something familiar about him.

Gejeje mu rugo, Barongera Bamusig
hira kumwica ubwa tabiri Bamututir
turimbi bagezeyo barongera habura
umwica barongera biamugarura mu
Ga Santre (Santre) Karaho habura
umwica ubwa 3 NIbwo bamufatag
bamujya ne imbere yo mu rugo Ahotware
dutuye

Nari Aho hafi mu Giti'cya Avo
cyo mu murima wari kumwe Naho twar
dutuye Bamwishe nabi birenze urugeri
bamwicana ubugome Babanje ku mucug
Ibyo yari yambaye igitenge ijipo bamus
GIRGI AGARIRA NA SUVE tement Ariko Nit
WETO ZA MUKASA BAZI MUREKERA NYUMA
BAKOZE UPUPINDO BWO KUMU BABAZA Bu
BAMUBAZA AHOTUZI yANGA Kuttubabwira
NIbwo Haje Interahamwe eshatu
tegera Elie, Semiryango, Karemo,
BASENE, TEGERA Agahohwiro

It was my brother.

For both of us our happiness was joined with tears.

We stayed near the field for three days. I would sleep up in a tree, watching for enemies, while my brother slept underneath. In the morning, I would tie his shirt to mine.

We wouldn't be separated again.

I never forgot that before she died my mother gave me the responsibility of taking care of my brother.

One night around 2 a.m. when I moved my hand, I discovered I'd put it in a beehive. The bees swarmed out and started stinging me. They made a lot of noise, but I kept quiet, fearing that the Interahamwe would hear and come kill us. Meanwhile, my brother was deep asleep under the tree.

When I was near dying, I fell out of the tree. But although the bees stung me mercilessly, I didn't get sick. That is hard to understand if you don't know the miracles of God.

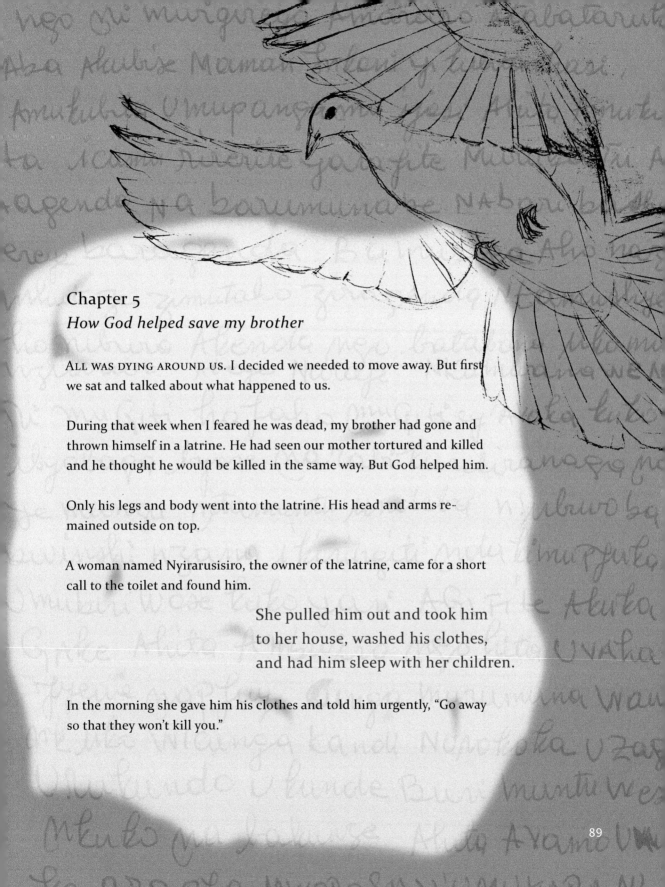

Chapter 5
How God helped save my brother

ALL WAS DYING AROUND US. I decided we needed to move away. But first we sat and talked about what happened to us.

During that week when I feared he was dead, my brother had gone and thrown himself in a latrine. He had seen our mother tortured and killed and he thought he would be killed in the same way. But God helped him.

Only his legs and body went into the latrine. His head and arms remained outside on top.

A woman named Nyirarusisiro, the owner of the latrine, came for a short call to the toilet and found him.

She pulled him out and took him
to her house, washed his clothes,
and had him sleep with her children.

In the morning she gave him his clothes and told him urgently, "Go away so that they won't kill you."

Chapter 6
Mama Christine's orphanage

I FELT VERY BAD FOR MY BROTHER. I took his hand and told him to follow me. We got ourselves into the middle of a crowd, including a group of people who were going to Gisenyi town to buy umusururu and walked along as invisibly as possible. We passed Interahamwe, whom fortunately I did not recognize. That is how we arrived in Gisenyi.

Umusururu: a local sorghum beer

The problem, then, was where to stay. I remembered a pastor named Hamuri of the ADERP church in Gisenyi. We went there and told him all that had happened to us.

ADERP: Association of Pentecostal Churches

He wrote a letter and gave it to us to take to an orphanage run by Mama Christine. When she saw us, we gave her the letter. She told us that she was sorry, but there was no more space.

90

We went back to Pastor Humuri. He sat us down and gave us food, which we couldn't eat, because we had spent so many days without food. Then he gave us porridge, which we took. After we ate, he went with us to plead with Mama Christine.

She accepted us and we stayed there.

The people who killed my mother came to kill in Gisenyi. They saw me. One ran after me, but I was able to escape.

Zaire: Earlier name of the Democratic Republic of the Congo

I asked the people who gave us shelter to find somewhere else to hide us. Many people in the orphanage had seen how they chased me.

It was decided that we would be taken to Zaire.

91

Chapter 7
In Zaire

IT WAS VERY HARD to cross the border.

My brother and I were put in two empty boxes. On top of the boxes, they placed piles of saucepans and clothes. It was stifling. That is how we survived.

For over a year we stayed with Mama Christine in her orphanage. Mama Christine was a Christian from the ADEPR church; she had 180 orphans. There they accommodated us until they built a shelter at Cyeshero.

In 1996 the Inkotanyi came, but Mama Christine refused to let us return to Rwanda. Instead she took us into the Congo forests. However, she had to go to Goma, and, while she was away, the Rwandan army found out where the orphans were living.

They came into the forest and took us away. We walked for several days.

During that journey in Zaire, I saw the man who replaced Juvenal Habyarimana burning his own Mercedes Benz and running into the forest with his sons and the ex-army.

Finally we crossed back into Rwanda.

Juvenal Habyarimana: Rwandan president, whose plane was shot down when he was returning from peace talks in Arusha, Tanzania; Jean Kambanda, sworn in as prime minister, April 9, 1994

93

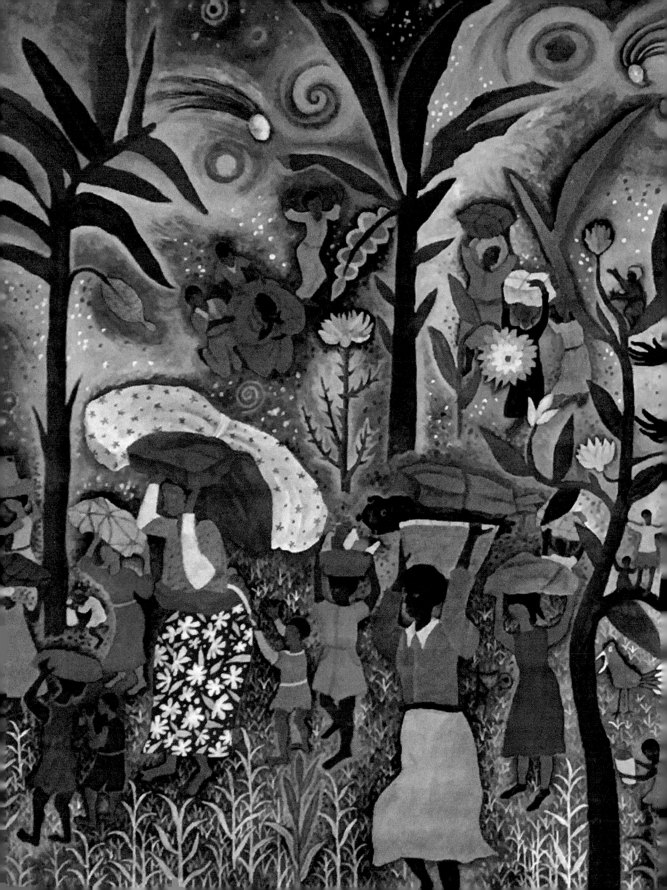

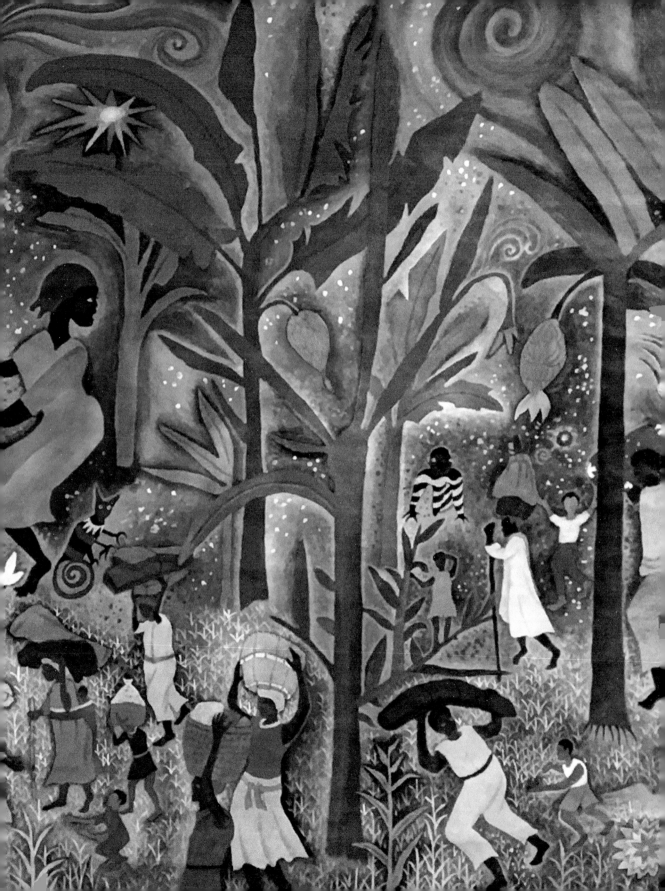

CHAPTER 8
Life in Rwanda

BACK IN RWANDA THE ICRC wanted to look for our family.

After a week, a land cruiser came with people determined to find
our home. They asked if we knew where it was. I told them that
we did, but there was nobody there now, that they were all killed
during the war.

They didn't believe me. So we went to find out.

ICRC:
International
Committee of
the Red Cross

We discovered that even our house had been destroyed. The
people asked our neighbors if they knew us. "Yes, we do," they
answered.

"They have no family."

They drove us back to a place called Kanseine and sometime
later took us to Mudende, to the orphanage of Mme. Rosamond
Halsey Carr.

There I started P3 and in 1999 completed primary school.

But the war kept overtaking me.

In secondary school, it utterly refused to leave and every week I would end up in the Gisenyi hospital. When I reached S2, it took possession of me and I turned the hospital into my home. The IBUKA representative advised me to stop for a while so I wouldn't develop even more problems.

IBUKA: translated "REMEMBER," an organization seeking to advance and coordinate survivors' projects on the national level

 I dropped out of school
 while my brother continued on.

Chapter 8
After the war, God answers in time

MAY 18, 2005, MY WORLD CHANGED. On that day
Uwicyeza Nzayisenga Angel came into my life.

She had had problems similar to mine. We met through our
problems. Eventually, we decided to stay together.

At the beginning it wasn't easy for us. Three months after we
were together, the people at the place where I worked asked me
to decide between having a wife or a job.

I had to leave my wife in order to continue my job or leave my
job to stay with my wife. I thought about the problems I had
passed through and her problems too.

I decided to stay with her, an orphan.

I quit my job.

I continued to look for a job that would give us something to eat. And we survived, my wife jobless and I working any job possible to earn a living.

Now we have two children, a girl named Cyusa Uwase Kevine and a boy named Nirworukundo Gift Crespo.

After five years I got a job at Ubumwe Community Centre for the handicapped. My wife got a benefactor, Mama Lily, who helped her learn sewing. After the training, she gave her a sewing machine. She also gave us a water tank of 1,000 litres. After that Mama Lily started a micro-loan program. I was given a loan out of it.

There was a long debate about burying my mother.

Some people said that she was one of the victims of the 1994 Genocide and others said that she was not.

God heard us and accepted her to be buried in honor like the others.

Fifteen years after her death, she was buried in the Rugerero Genocide Memorial.

There is no other mother like Nikuze Agnes.

We will always remember you.

You died to save our lives.

After the war, my brother went back to school supported by the government. In October of this year, 2009, he will graduate from a university.

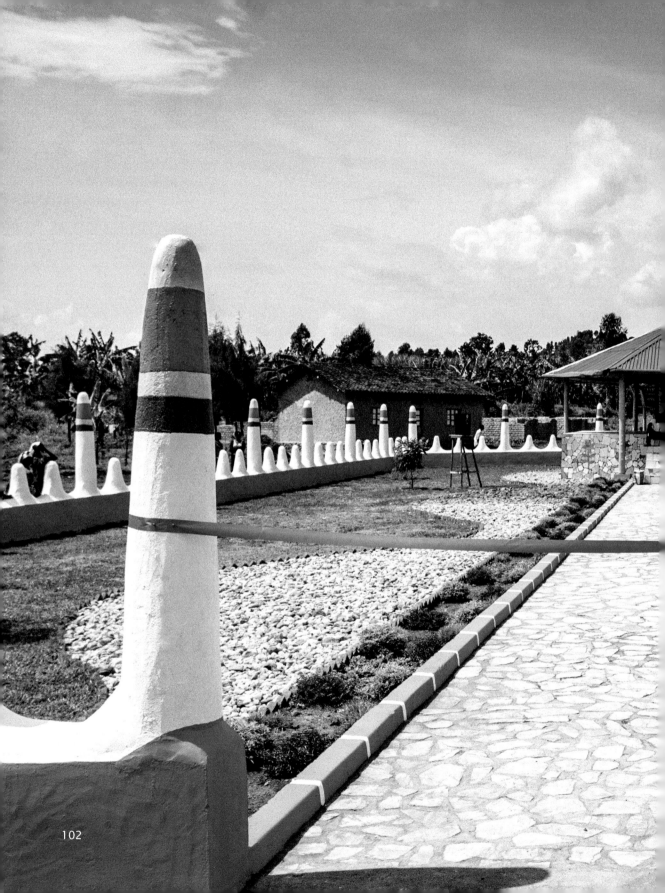

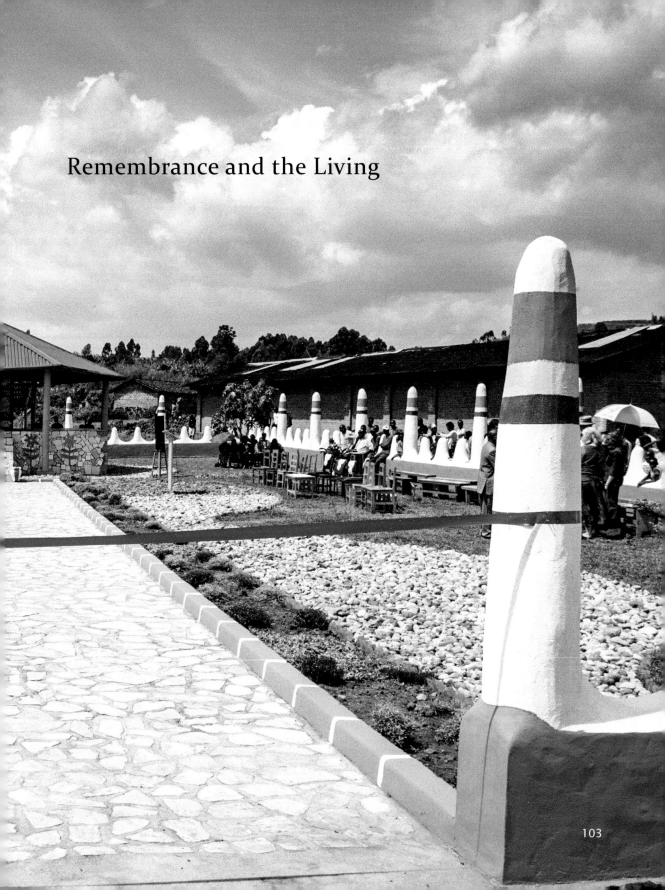

Remembrance and the Living

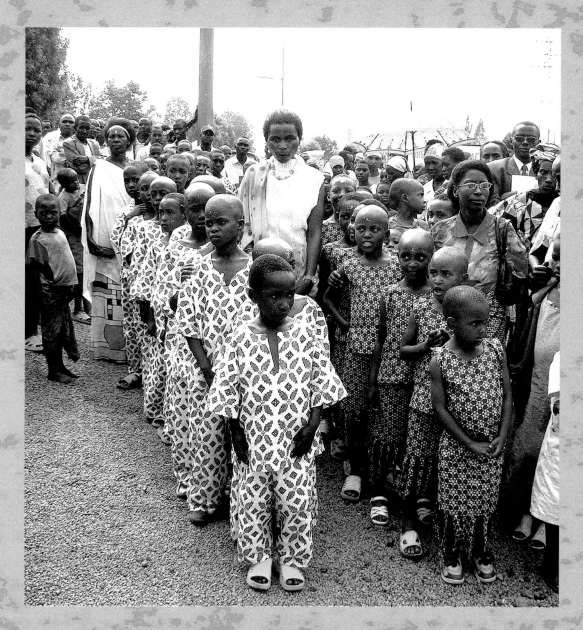

April 5, 2007, Dedication of the Rugerero Genocide Memorial

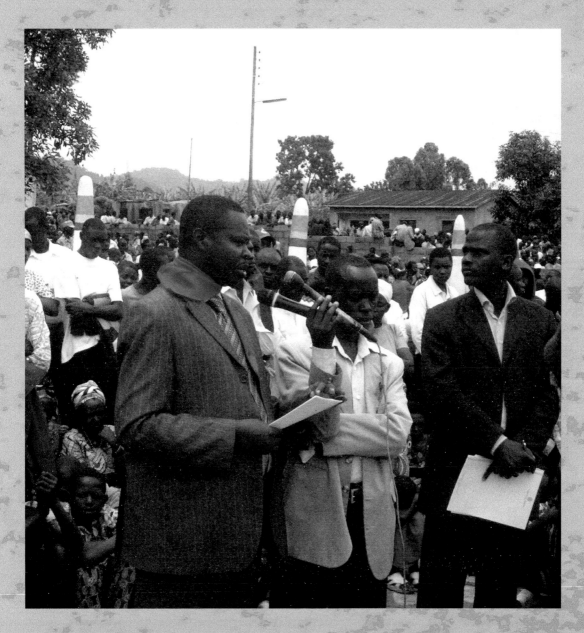

Mazimpaka Emmanuel, Executive Secretary of Rugerero Sector

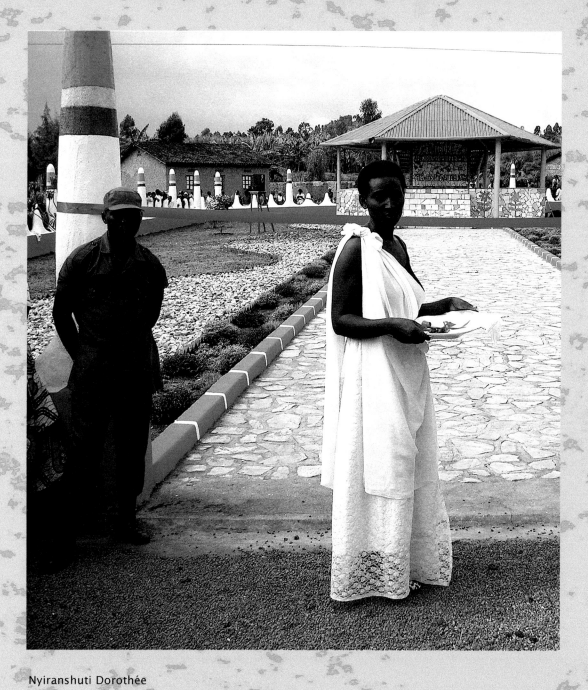

Nyiranshuti Dorothée

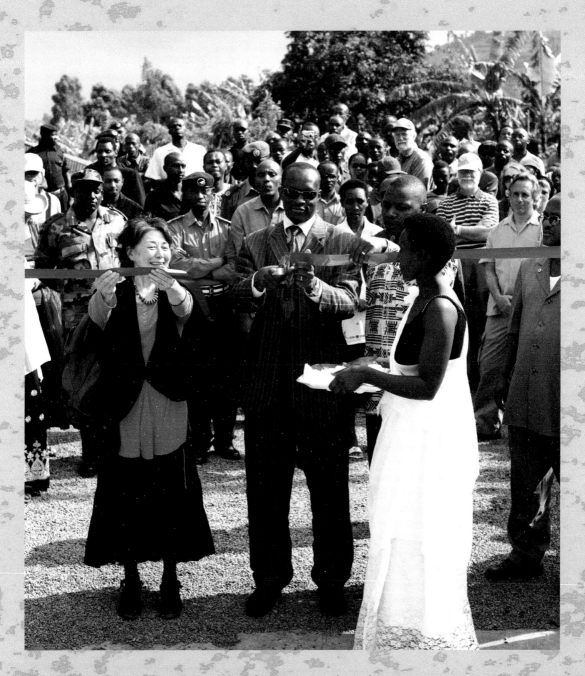

Lily Yeh and Joseph Habineza, Minister of Culture, Youth, and Sports

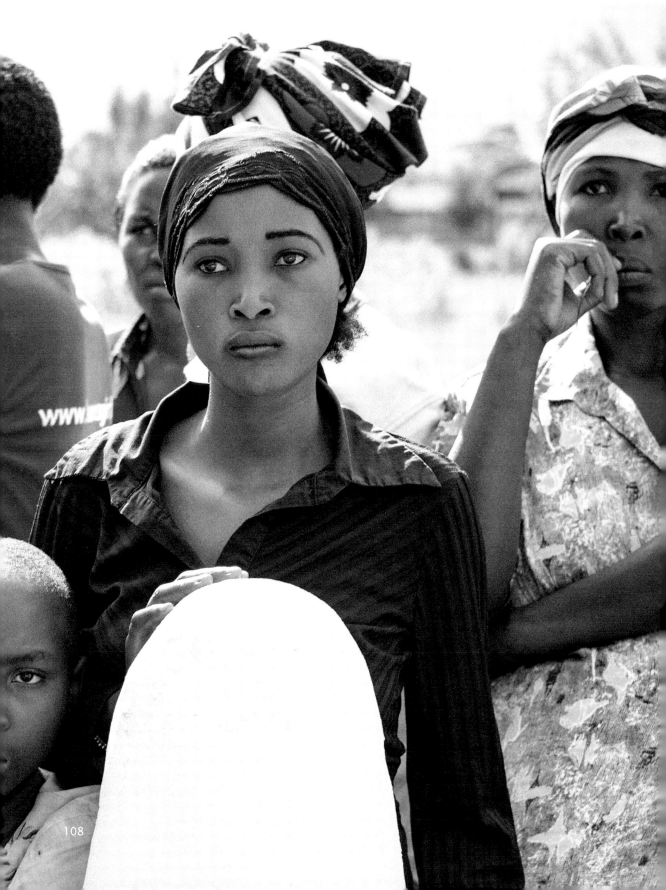

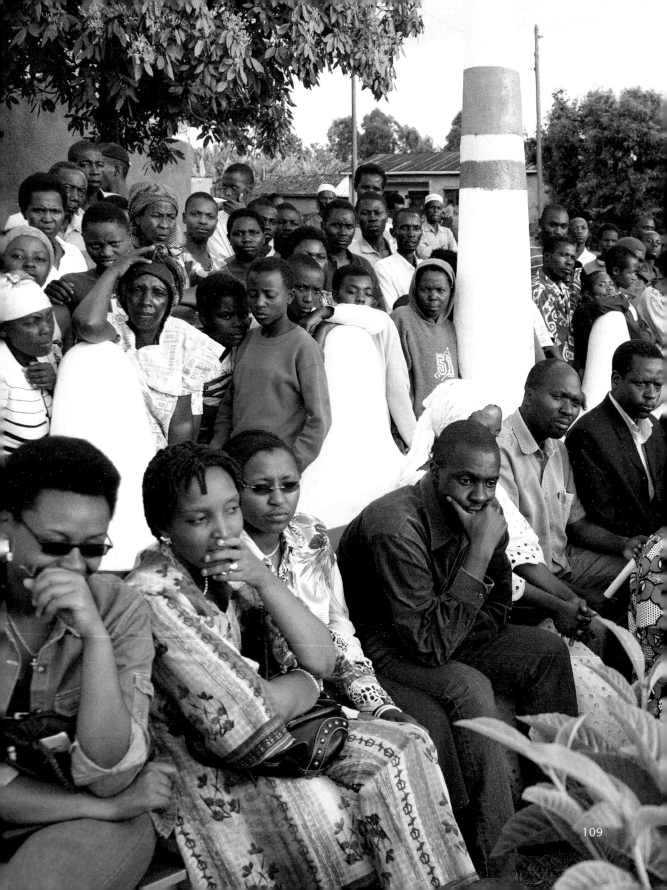

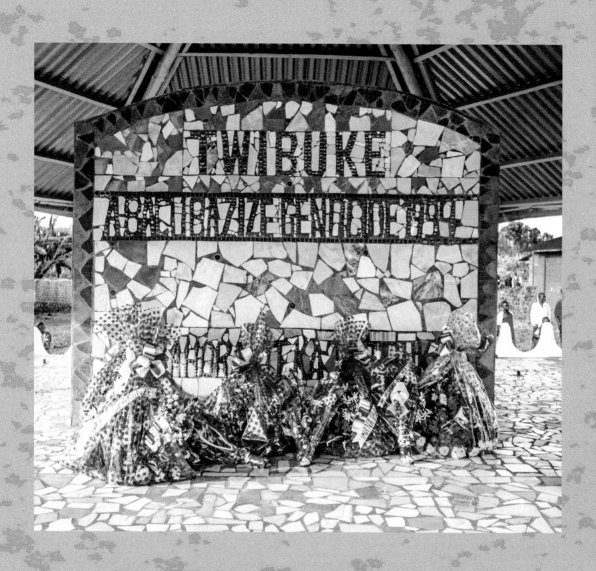

Remember

Our Relatives Died in the 1994 Genocide

We Will Never Forget Them

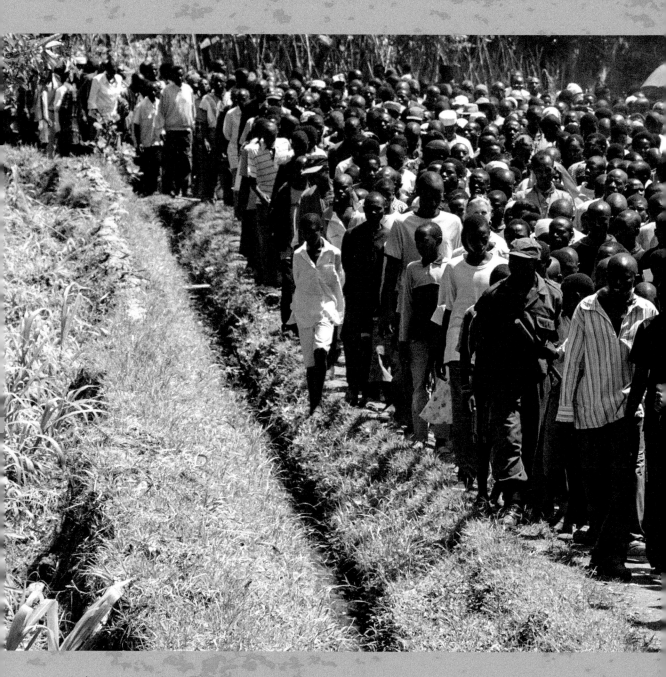

Each year on April 7, the National Day of Mourning,
all over Rwanda there are processions stopping at various sites.

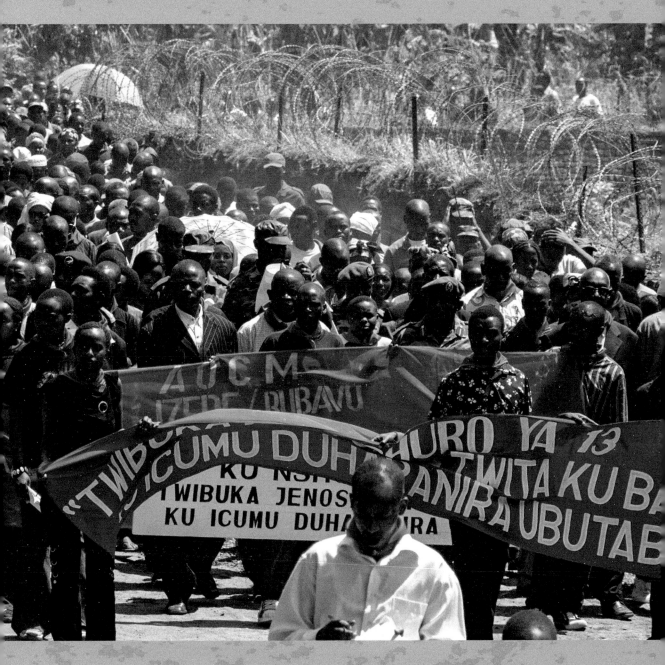

Names read, stories told, prayers. Memorial sites, body chambers.

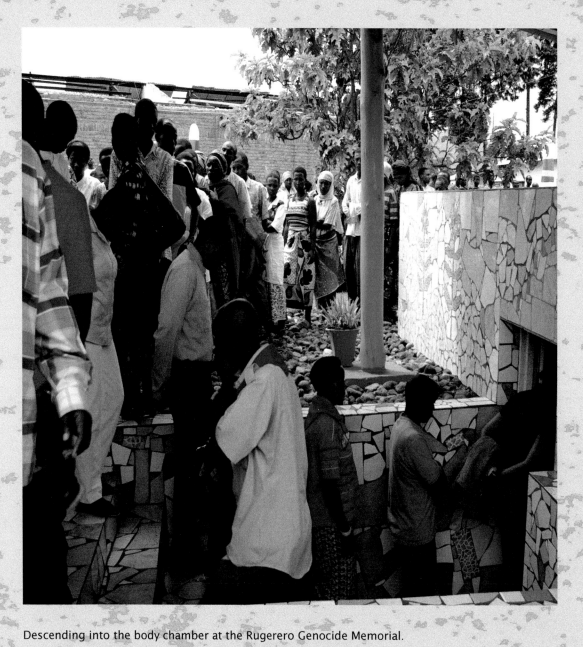

Descending into the body chamber at the Rugerero Genocide Memorial.

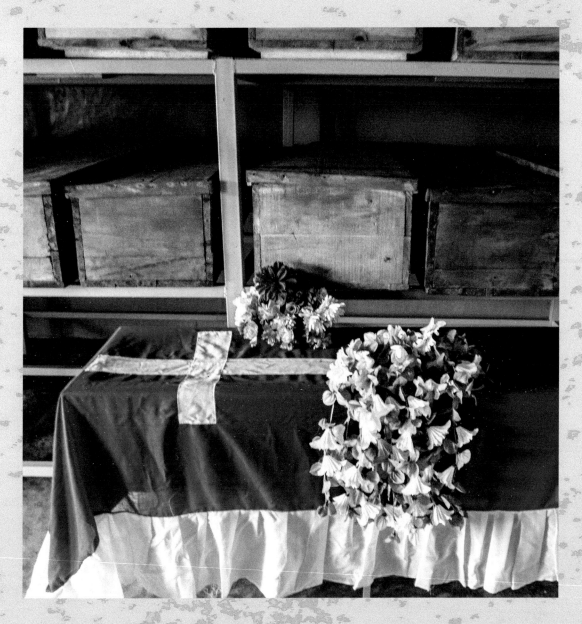

"Now the bodies of our loved ones are being honored."
Mutumyinka Clementine

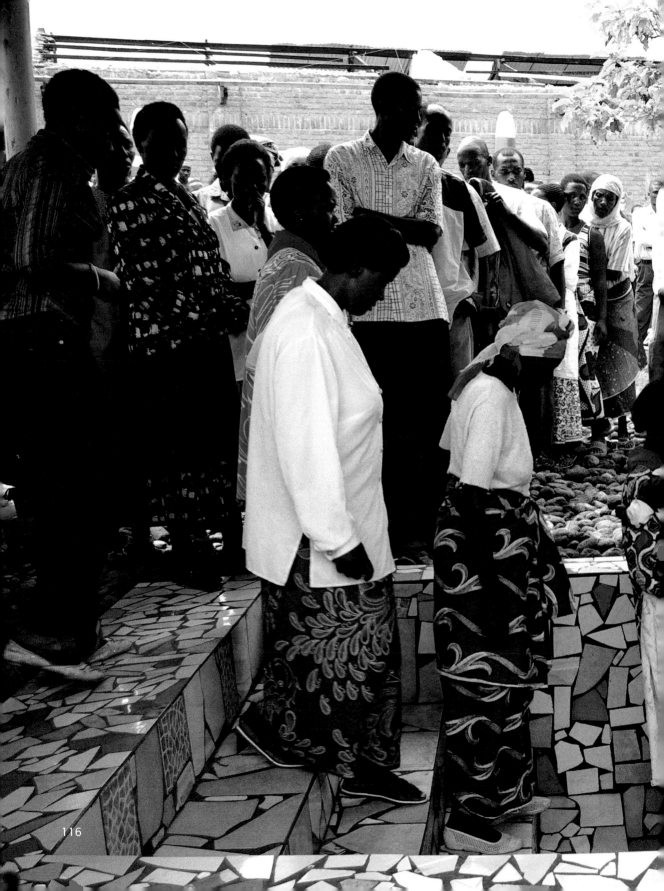

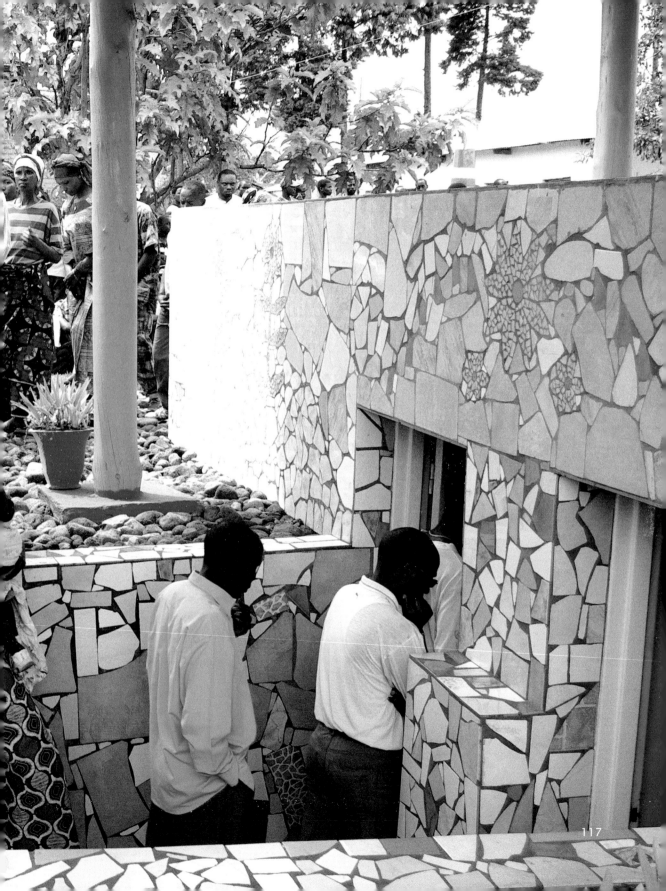

117

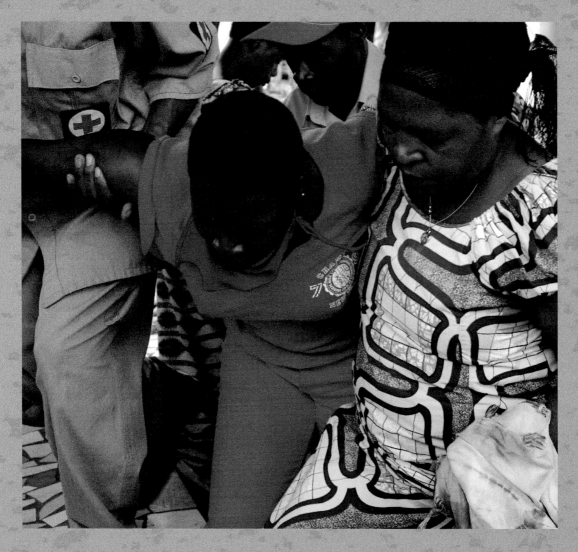

"The memorial helped me be able to join other people, which is a process of healing."
Mukagatare Melanie

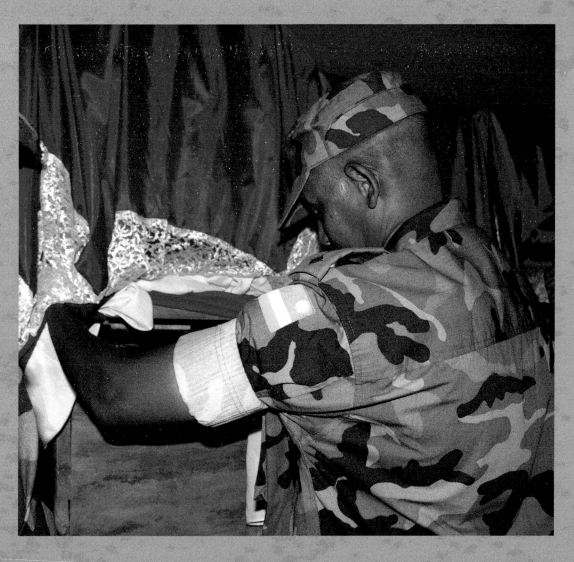

"When I am here I am not alone. I am here with my family."

Nyiranshuti Dorothée

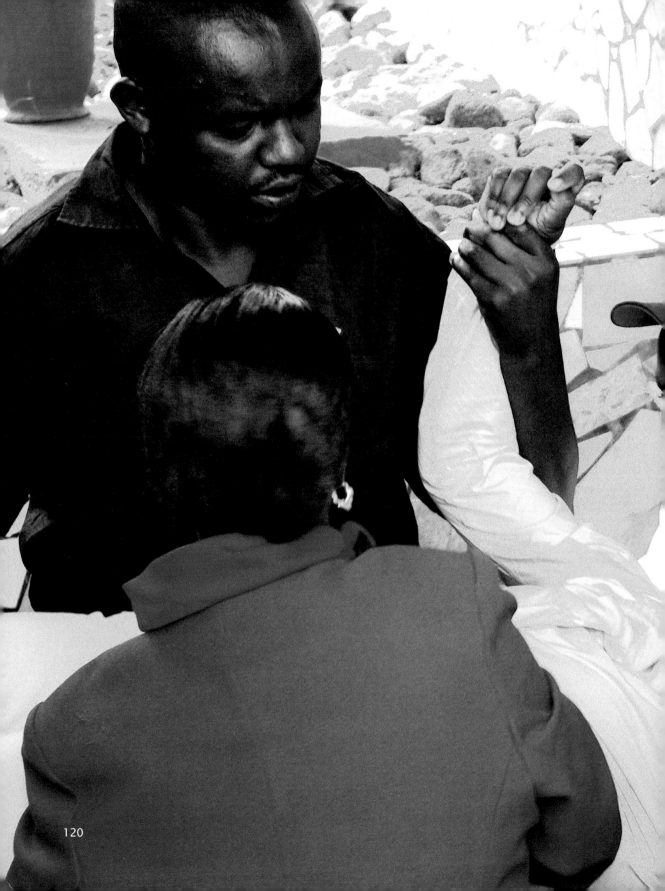

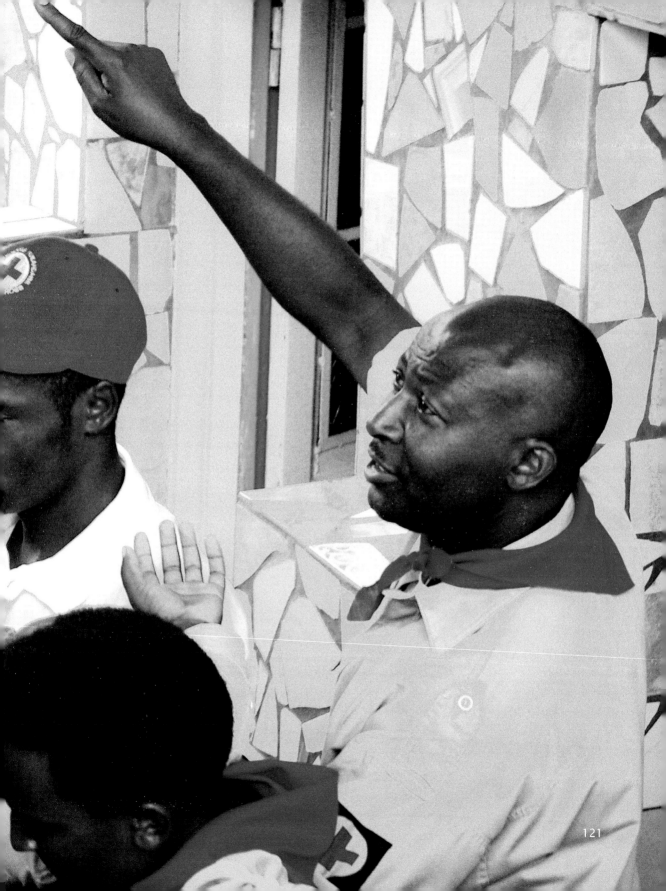

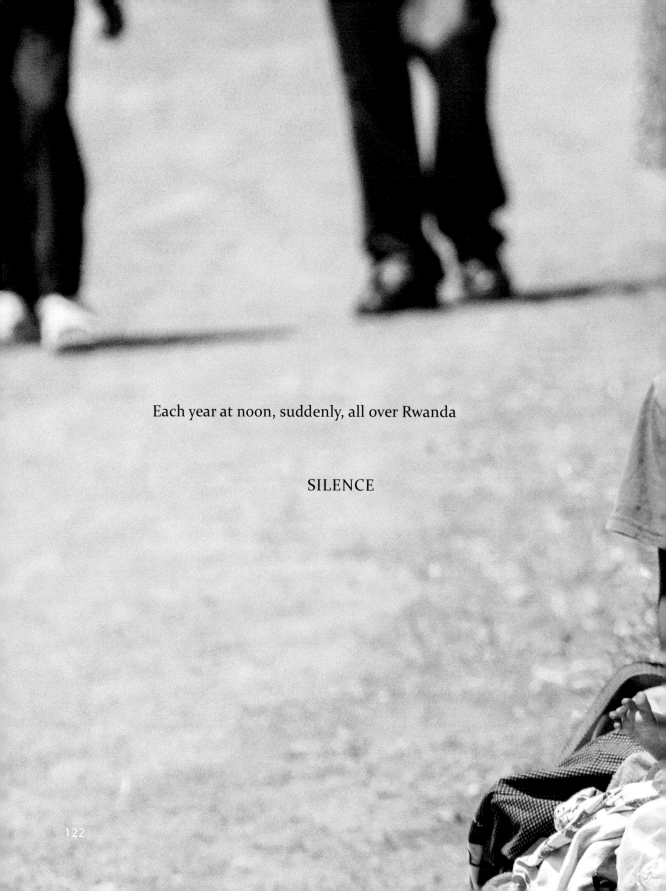

Each year at noon, suddenly, all over Rwanda

SILENCE

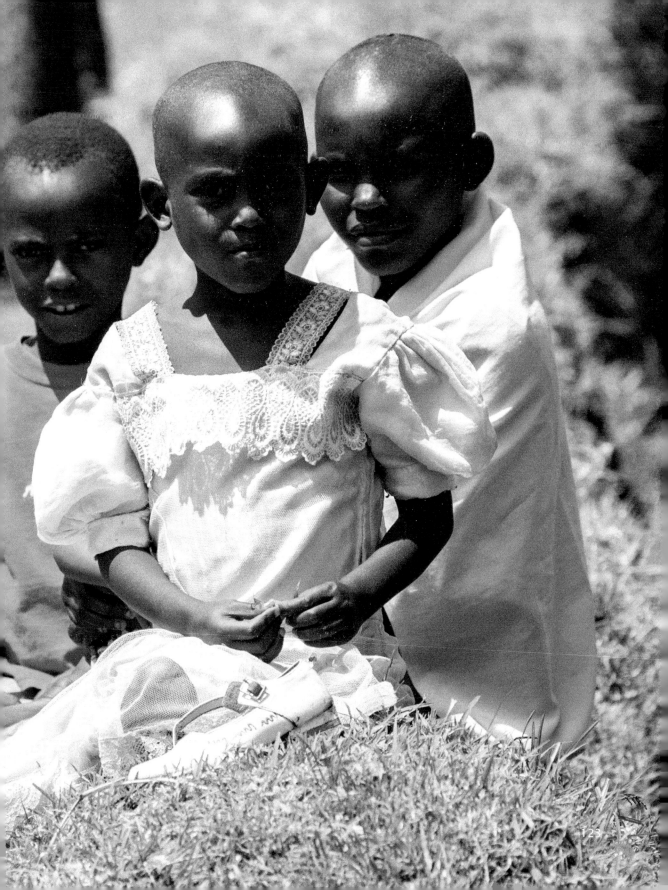

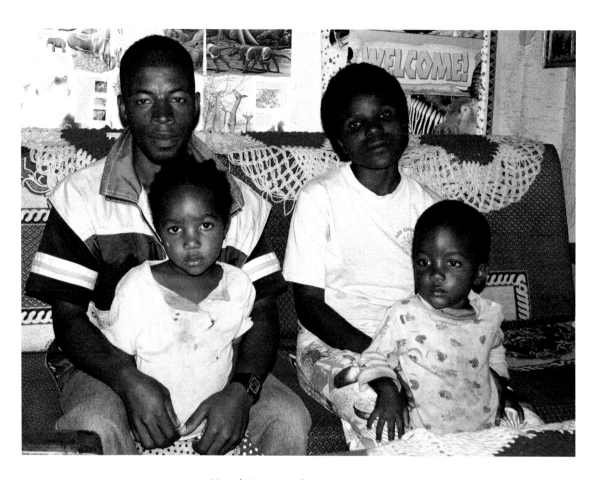

Musabyimana John Peter Sammy
and Uwicyeza Nzayisenga Angel
and their children
Cyusa Uwase Kevine and Nirworukundo Gift Crespo

Epilogue and Credits

From Susan Viguers:

Lily Yeh, who has worked for many years with the people of Rugerero under the auspices of Barefoot Artists, is the original source, indirectly or directly, of everything in this book. She is also the creator of the drawings and paintings. I conceptually focused the book, composed the text, sought out the photographs, and created and choreographed, visually and verbally, the pages. Along with those roles, we each participated significantly in the other's contributions to the book. This has been a genuine collaboration.

I am an outsider. This may not be exactly the story or the form of the story that the people of Rugerero would tell. But it is a deeply felt envisioning of their lives, the extraordinary tragedy they survived, and the courage necessary for surviving, based on what they have said and written and drawn and the lives they have created and the humanity and beauty they embody.

The story of Uwicyeza Nzayisenga Angel (pp. 38-67) draws from several sources: a transcript of an interview translated into English by Rudasingwa Felix, the text she wrote to accompany some of her drawings translated by Rukatsi Nadine and Rudasingwa Felix, and recollections of her by Lily Yeh. The story of Musabyimana John Peter Sammy (pp. 70-101) is based on the text which he entrusted to Lily Yeh. He told his own story as he experienced it, with only one exception, some details of his mother's torture which he couldn't have seen. It has been recast for clarity and pacing, but the events and the voice (through his translator Rudasingwa Felix) are his. The brief passages in the section on the building of the Rugerero Memorial (pp. 22-33), are excerpts from interviews of the young women in Lily Yeh's storytelling workshops, translated by Rudasingwa Felix. "Homily" is from *The Selected Poetry of Dan Pagis*, translated by Stephen Mitchell (Berkeley: University of California Press, 1989).

The quotations of Mutumyinka Clementine (p. 115), Mukagatare Melanie (p. 118), and Nyiranshuti Dorethée (p. 119) come from various interviews in the Survivors Village, again translated by Rudasingwa Felix.

Many of the drawings and paintings by Lily Yeh are influenced by the art created by the young women in her workshops, as is the background pattern for the Angel story. The photographs, besides those by Lily Yeh, are by people who joined Barefoot Artists in Rugerero. Specific captions and credits for images and photography are listed below.

From Lily Yeh:

I would never have dreamed of working on a book relating to the 1994 Genocide against the Tutsi. The scale of the event with its unfathomable darkness and human suffering would have paralyzed me in the attempt. But the urgency of Musabyimana John Peter Sammy in telling and sharing his story changed my mind.

Sammy was not in my workshop and I was not aware of his experiences during the 1994 Genocide. In 2009 after I conducted an interview with his wife, Uwicyeza Nzayisenga Angel, in their home, Sammy handed me a stack of thin paper in different sizes filled with his writings. He said to me, "This is my story. Please translate it into French and English. I want to share my story with the world."

This gift felt like a heavy burden and I could not see how his request could be done. I asked Rudasingwa Felix to translate the script so that, at least, I could understand it. His story began to haunt me and so did the stories of all the women who participated in my workshops. I have a sense that these stories do not belong to me; they belong to the world as a part of the collective human experience. I met with Susan, who as a book artist has seemed a magician to me, her words singing between lines and all spaces poignant with meaning, and together we began to conceive of creating a book.

My deep gratitude goes to Angel and Sammy for entrusting me their life-shattering stories. The compelling narratives, the relentless details, the depth of horrors and anguish helped me grasp the capacity of us human

beings in committing atrocity. Their courage to remember and their audacity to love and keep faith give me the strength to hope and to pursue this project. I am profoundly grateful to all the women who participated in my workshop over a three-year period. The authenticity of their stories and their art works guided Susan and me in the making of this book.

Imagery Credits

Patterns and illustrations

The clouds and the page spread background imagery and color are by Susan Viguers. The map drawing of Rwanda is also hers. The background pattern on the Angel pages is based on a part of a drawing by Mukagasana Marie. The background imagery behind the Sammy section is a scan of one of the spreads from his notebook in which he wrote his story.

The drawings integrated into the page spreads and the three paintings are by Lily Yeh. The drawing to the left of the title page is her design of the Regerero Genocide Memorial Site, as are the sketches on pp. 20-21. The following are the images that draw on works by various workshop participants:

Woman Carrying Wood, p. 38, based on drawings by Niyonsaba Esperance, Nyiraneza Alexie, and Uwicyeza Nzayisenga Angel

Storytelling Workshop, p.40, guided by photographs taken by Jean Bosco Musana Rukirande of early workshops

Singing and Sewing, pp. 50-51, derived from the works of Nyiraneza Alexie and Mukamana Justine

Crying Woman, p. 54, inspired by a drawing by Niyonsaba Esperance

Quite a Person, p. 72, based on a drawing by Imanashimwe Françine

Banana Trees, pp. 84-85, references came from the works of Niyonsaba Esperance, Mukamana Justine, Uwicyeza Angel, and Uwizeyimana Jacqueline

Banana Grove, pp. 92-93, based on work by children in the village

Gift of Love, pp. 98-99, inspired by the work of Mukamana Justine and that of all participants in the workshop

Photographs

Map of (Colonial) Africa on a Wall, Christopher Landy

Rwandan Landscape, pp. 2-3, Christopher Landy

Path Between Fields, pp. 4-5, Daniel Traub

Bodies at the Murambi Genocide Memorial Centre, pp. 6-7, Daniel Traub

Rugerero Children Dancing, p. 9, Lily Yeh

Skulls at the Murambi Genocide Memorial Centre pp. 10-11, Daniel Traub

Rwandan Landscape with Ruins, pp. 12-13, Christopher Landy

Altar in a Home, Rugerero Survivors Village, pp. 14-15, Christopher Landy

Lake Kivu, pp. 16-17, Christopher Landy

Unmarked Mass Gravesite, Rugerero, p. 19, Lily Yeh

Tractor and Workers, p. 22, Lily Yeh

Men Digging, pp. 22-23, Lily Yeh

China Road and Bridge Construction Company with Workers, p. 23, Lily Yeh

Children at Play, Anxious to Help in the Construction, p. 24, Lily Yeh

Early Proposed Layout for Rugerero Memorial Site, pp. 24-25, Lily Yeh

Preparing a Wall for the Mosaic, p. 25, Lily Yeh

Nyirimanzi Watering a New Tree, p. 26, Lily Yeh

Painting Walls of the School Next to the Memorial Site, pp. 26-27, Daniel Traub

Boys Painting, p. 27, Daniel Traub

Mugorewindekwe Consolee and Nyiranshuti Dorothée Preparing Sand for the Cement, p. 28, Christopher Landy

Nzabonimpa Jean de Dieu Plastering, pp. 28-29, Christopher Landy

Mutumyinka Clementine Drawing in Preparation for Mosaics, p. 29, Christopher Landy

Preparing the Mosaics, p. 30, Christopher Landy

Mutumyinka Clementine Placing Mosaic Piece, pp. 30-31, Christopher Landy

Bitwayiki Marcel Working on the Mosaic, p. 31, Christopher Landy

Cleaning in Preparation for the Dedication, p. 32, Christopher Landy

Nyiranshuti Dorothée Mopping, pp. 32-33, Christopher Landy

Mosaic Tablet on the Platform of the Memorial, p. 33, Christopher Landy

Rugerero Genocide Memorial Site, pp. 34-35, Lily Yeh

Memorial Before the Dedication, pp. 102-103, Christopher Landy

Children Lined Up for the Dedication, p. 104, Lily Yeh

Dedication Ceremony Speaker, p. 105, Daniel Traub

Nyiranshuti Dorothée at the Dedication, p. 106, Christopher Landy

Cutting the Ribbon, p. 107, Christopher Noble

Watching the Dedication Ceremony, p. 108, Daniel Traub

Dedication Ceremony Audience, p. 109, Daniel Traub

Memorial Tablet at the Dedication, p. 110, Christopher Landy

Day of Remembrance, Nyundo, pp. 112-113, Christopher Landy

Into the Body Chamber, p. 114, Lily Yeh

Inside the Body Chamber, p. 115, Christopher Landy

Descent into the Body Chamber, pp. 116-117, Lily Yeh

Stuggling with the Pain, p. 118, Lily Yeh

Soldier Looking into a Casket, p. 119, Lily Yeh

Woman Overcome, pp. 120-121, Lily Yeh

Day of Remembrance, Three Children, pp. 122-123, Christopher Landy

Family, p. 126, Lily Yeh

To learn more about the Barefoot Artists' Rwanda Healing Project, see the website www.barefootartists.org and *Finding Beauty in a Broken World* by Terry Tempest Williams (NY: Pantheon, 2008). We are deeply grateful to Jean Bosco Musana Rukirande, whose wisdom and organizing skills made the project in Rwanda possible and, thus, also this book.

Our thanks also to the College Book Art Association for a Project Grant and to the Rockefeller Foundation for the extraordinary opportunity of a Bellagio Arts Residency, which was hugely instrumental in the creation of this book.